Contents

Dedication

This book is dedicated to my brother, and all of those brothers and sisters who were killed in Vietnam.

Brother

Only memories of you my brother have I left to ease the pain, only memories as of sunshine that is banished by the rain. With the autumn flowers you faded and with them have gone to rest. Forgive me in my anguish, for perhaps thou knowest best. All in vain I try to fathom why you went to Vietnam, was your gallant soul concealing, what we know so well today? That you were a true American and believe in the American way, and now have gone away. Winter's winds will sigh in mourning, spring will bring the flowers once more, to embellish summer's grandeur, then to die at autumn's door. Some day God will call to me, and I will set forth, but perhaps it's a sunny morning and I will find a garden fair, full of flowers and little children, and my Brother will be there. Smiling he will come to meet me, and I think I hear him say, "Did you say that you had missed me? Why I haven't been away."

For Sgt. Jerry R. Dundas
Killed at Khesanh, Vietnam on 5/5/68
from his brother, Prof. James L. Dundas

Preface

Toy collecting is one of the fastest growing collectible fields of the 1990s. Toys that sold for a dime in the 1940s and 1950s can be worth hundreds of dollars now, and it looks like the prices are only going one way—up! Why all the interest in old toys? There has always been interest in antique toys from the 1800s through the 1920s and 1930s. Collectors of toys from that era have been particularly interested in cast iron toys like banks, which now cost hundreds or even thousands of dollars. The toys of the 1940s, 1950s, and 1960s are eagerly sought after—not just for nostalgic reasons, but also for the money that can be made in selling them.

Unfortunately, not many of us were able to keep everything from our childhoods—we wouldn't have been able to get into the house! As a result, those of us born after 1945—baby boomers—are now searching for the toys we grew up with: "I want the old toys that my mom threw out, or that my brother broke when I was a kid," we say. If you have a display of toys from the '40s, '50s, and early '60s that you can show your friends, you will frequently hear, "I had one of those!" Then you can say, "Well, I still do."

Toy whistles are a low-key collectible and still have low prices, although some have increased a great deal. I think that after reading this book you will find a lot of pleasure and reward in collecting different types of whistles. There are hundreds of them out there!

James Lee Dundas
Professor, Macomb
 Community College
Warren, Michigan

Whistles
An Explanation

What is a whistle? A whistle is a clear, musical sound made by the rapid movement of air over a surface. It can be produced by forcing air through the lips, or through a wide variety of noise-making devices also known as whistles. The sounds produced can be sweet, shrill, or sharp, all depending on the type of whistle used.

There are many kinds of noisemakers that may be confused with whistles. There are some important distinctions, however.

In some ways, flutes are similar to whistles. A flute has finger holes and keys on the side, and a mouthpiece without a reed. A whistle has one or more holes, but no finger holes to control the pitch. Dictionaries state that there is little difference between a flute and a whistle, since they generate sound in the same way.

Horns, on the other hand, work much differently; they produce sound by means of vibration. Horns like clarinets and oboes have a vibrating reed, which forces the air to oscillate as it passes over. Horns like trumpets, trombones, or even simple party noise-makers cause the lips to vibrate, and again the air oscillates to make the sound.

The difference between whistles and horns should be clear. Horns cause a vibration in your lips or a reed, while whistles and flutes make their sounds by the rapid movement of air over a surface.

About Plastic

The plastics are a large group of synthetic materials whose structures are based on the chemistry of carbon. An important charateristic of plastics is that they can be readily molded into finished products by the application of heat.

The first plastic toy whistles were made of celluloid. Invented in 1856, this material was used initially as a substitute for ivory in small items such as billiard balls, combs, and piano keys. Many toys including whistles were made of celluloid, which is light for its mass, hard, and very flammable. It could also be fragile.

Bakelite was invented next, in 1909. This plastic was heavy, hard for its mass, a little brittle, and almost noncombustible. Because of these characteristics, it soon replaced celluloid.

Then came hard plastic, which is very brittle. Some hard plastic items are 'variegated', or mixed with swirls of different colors or shades of the same color. This was done when manufacturers molded different colors of scrap plastic together in order to economize, and variegated whistles were therefore made of cheaper plastic. If a whistle comes in a solid color, it was made from a higher grade of plastic.

Shortly before World War II, soft plastic ('vinyl') was developed. Vinyl is flexible and lightweight; it is the cheapest kind of plastic. It does not have the richness of color or the shine of hard plastic, nor can it be molded with detailing as fine as that molded into hard plastic.

If you can determine what a whistle is made of, it should give you some idea of when it was manufactured. Here is a simplified guide:

> Celluloid: 1920 - 1930
> Bakelite: 1930 - 1940
> Hard plastic (variegated): 1940 - 1950
> Hard plastic (solid colors): 1940 - present
> Vinyl: 1970 - present

Patent Numbers
and Other Ways to Date Your Whistles

There are a few kinds of marks that can help you determine when a whistle was made. These marks include patent numbers (the dates of which can be determined through the chart I have provided), zip codes and area codes, and marks like "Made in Japan." While these markings may not pinpoint a manufacturing date, they can provide clues.

Patent Numbers

Patent numbers were assigned to new inventions in numerical order, beginning with #1 in 1836. If your whistle has a "Pat. No." marking, you can determine the year it was granted a patent, and thus the earliest possible date of its manufacture. The chart I have provided here shows the first number assigned in each year, up through 1992. Check the number marked on your piece, and then refer to the chart. If a patent number is between 2185170 and 2227417, the object was manufactured in 1940 at the earliest; if the number is between 2227418 and 2268539, it was made no earlier than 1941. Keep in mind that the number indicates only the *beginning* year of production; the whistle may have been made for years afterwards as well. In fact, it may still be in production today, though this is unusual since patent numbers expire after seventeen years.

Postal Codes

Another way to date whistles can be used if a company address appears on the whistle or the package. New York postmaster Mr. Walker introduced a two-digit area code for large cities on May 6, 1943, and five-digit zip codes were implemented on July 1, 1963. In October 1984 a four-digit number was added to zip codes. If your whistle shows an address, check for a postal code of this sort.

If the address does not include a code, then it may be older than May 6, 1943. Remember that two-digit area codes were used only in large cities, though; towns and cities with only one post office had no area codes between 1943 and 1963. But if your whistle does have a two-digit area code, then it was made between 1943 and 1963.

If the address has a five-digit zip code, then the whistle was made between 1963 and 1984.

If the address has a zip code with five digits followed by an additional four digits, it can be no older than October 1984. For example:

John Doe Toys
123 Main Street
Detroit, Mich. (Possibly older than May 6, 1943)

John Doe Toys
123 Main Street
Detroit 09 Mich. (Made between 1943 and 1963)

John Doe Toys
123 Main Street
Detroit, Mi. 48207 (Made between 1963 and 1984)

John Doe Toys
123 Main Street
Detroit, MI 48207-1144 (Made after 1984)

Occupied Japan

The words "Occupied Japan" printed on an item indicate that it was manufactured in Japan during a very specific period. Japan was occupied by the U.S. Army at the end of World War II, from late August 1945 to April 28, 1952. During that period, products were marked "Occupied Japan" or "Made in Occupied Japan."

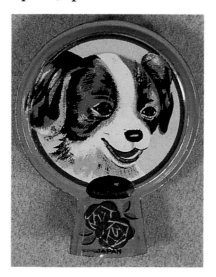

PATENT LIST

YEAR	1ST PATENT	YEAR	1ST PATENT	YEAR	1ST PATENT
1836	1	1889	395305	1941	2227418
1837	110	1890	418655	1942	2268540
1838	546	1891	443987	1943	2307007
1839	1061	1892	466315	1944	2338061
1840	1465	1893	483976	1945	2366154
1841	1923	1894	511744	1946	2391856
1842	2413	1895	531619	1947	2413675
1843	2901	1896	552502	1948	2433824
1844	3395	1897	574369	1949	2457797
1845	3873	1898	596467	1950	2492944
1846	4348	1899	616871	1951	2536016
1847	4914	1900	640167	1952	2580379
1848	5409	1901	664827	1953	2624046
1849	5993	1902	690385	1954	2664562
1850	6961	1903	717521	1955	2698434
1851	7865	1904	758567	1956	2728913
1852	8622	1905	778834	1957	2775762
1853	9512	1906	808618	1958	2818567
1854	10358	1907	839799	1959	2868973
1855	12117	1908	875679	1960	2919443
1856	14009	1909	908430	1961	2966681
1857	16324	1910	945010	1962	3015103
1858	19010	1911	980178	1963	3070801
1859	22477	1912	1013095	1964	3116487
1860	26642	1913	1049326	1965	3163365
1861	31005	1914	1083267	1966	3226729
1862	34045	1915	1125212	1967	3295143
1863	37266	1916	1166419	1968	3360800
1864	41047	1917	1210389	1969	3419907
1865	45685	1918	1251458	1970	3487470
1866	51784	1919	1290027	1971	3551909
1867	60658	1920	1326899	1972	3633214
1868	72959	1921	1354054	1973	3707729
1869	85503	1922	1401948	1974	3781914
1870	98460	1923	1440352	1975	3858241
1871	110617	1924	1478996	1976	3930271
1872	122304	1925	1521590	1977	4000520
1873	134504	1926	1568040	1978	4065812
1874	146120	1927	1612700	1979	4131952
1875	158350	1928	1654521	1980	4180876
1876	171641	1929	1696897	1981	4242757
1877	185813	1930	1742181	1982	4308622
1878	198753	1931	1787424	1983	4366579
1879	211078	1932	1839190	1984	4423523
1880	223211	1933	1892663	1985	4490885
1881	236137	1934	1941449	1986	4562596
1882	251685	1935	1985678	1987	4633526
1883	269320	1936	2026516	1988	4716594
1884	291016	1937	2066309	1989	4794652
1885	310163	1938	2104004	1990	4890335
1886	333494	1939	2142080	1991	4980927
1887	355291	1940	2185170	1992	5077836
1888	375720				

How to Clean Whistles

You should be very careful when cleaning whistles so you do not remove any decals, labels, or printing.

On plastic whistles, use warm disinfectant soapy water and Meguiar's Mirror Glaze plastic cleaner.

On tin lithograph whistles, use warm disinfectant soapy water and Meguiar's Mirror Glaze #7 show car polish.

On brass use warm disinfectant soapy water and a brass polish like Never-Dull or a little buffing.

On silver use warm disinfectant soapy water and Goddard's Long Shine Silver Foam or a little buffing.

On chrome use warm disinfectant soapy water and any chrome cleaner.

On wood use a disinfectant like Hibiclens and very little water to keep the wood from warping. Then wax with a furniture polish like a table wax.

Whistles

Advertisement Whistles

"Keds Supersonic Space Whistle," 2 1/4"
x 2" x 3/16", made of plastic. (#1)
/5-20

"Cap'n Crunch Bo'sun Whistle," 3" x 1"
x 3 1/6", two tones, made of hard
plastic. (#2) /5-20

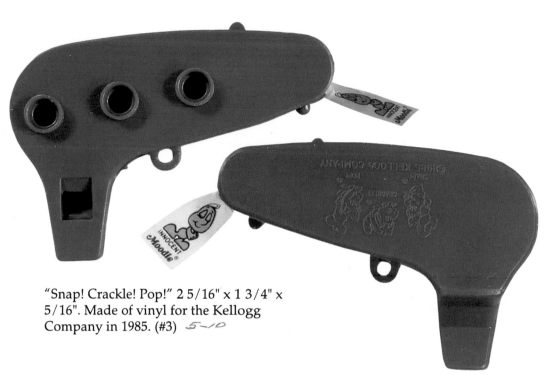

"Snap! Crackle! Pop!" 2 5/16" x 1 3/4" x 5/16". Made of vinyl for the Kellogg Company in 1985. (#3) 5~10

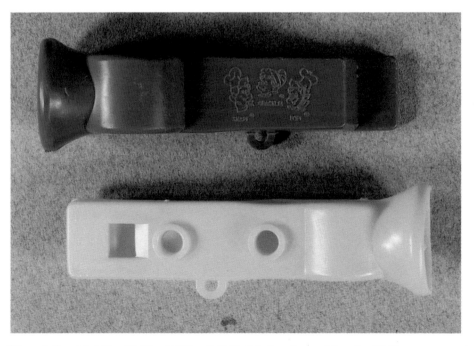

"Snap! Crackle! Pop!" 3" x 7/8" x 5/16". Made of vinyl for the Kellogg Company. Comes in assorted colors. (#4) 5~10

"McDonald's Tootler," five tones. Made of plastic for McDonald's in 1985. (#5) 2~4

"Come home for the holidays, LAKESIDE." Three tones, made of hard plastic, 2 3/4" x 1 1/8" x 1/4". Made in the U.S.A. (#6) 4~6

"Enjoy Coca Cola." Three tones, made of hard plastic, 2 3/4" x 1 1/8" x 1/4". Made in the U.S.A. (#7) 5~10

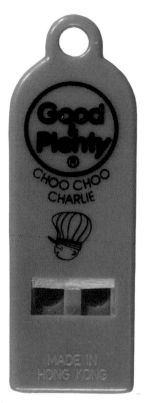

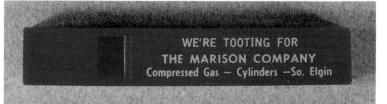

"We're tooting for the Marison Company," 2 7/8" x 1/2" x 5/16". Made of hard plastic. (#11) *15-20*

"Good & Plenty, Choo Choo Charlie." Two tones, 2 5/8" x 7/8" x 3/16", made of plastic in Hong Kong. (#8) *10-15*

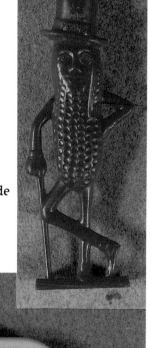

Mr. Peanut, 2 1/2" x 3/4" x 3/16". Made of plastic. (#9) *10-15*

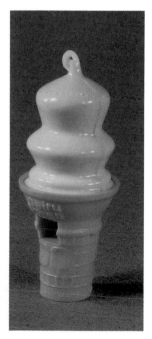

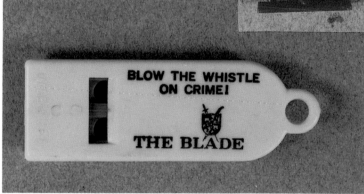

"Blow The Whistle On Crime! The Blade." Two tones, 2 5/16" x 7/8" x 3/16". Made of plastic. (#14) *3-5*

"Dairy Queen," 3" x 1 1/4". Made of hard plastic in Canada. (#10) *10-15*

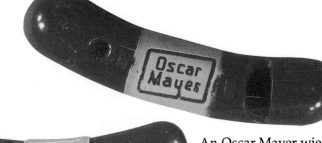

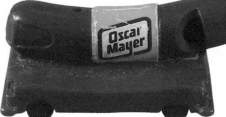

An Oscar Mayer wiener, 2 1/8" x 1/2". Two tones, made of plastic. (#13) *10-15*

An Oscar Mayer wiener, 2 1/4" x 1 1/4" x 7/8". Two tones, made of plastic. (#12) *10-15*

"Bob-lo," 2 3/4" x 1 1/8" x 1/4". Has three tones and is made of hard plastic. Bob-lo is an island near Detroit, MI. Made in the U.S.A. (#15) *3-5*

"Vote Republican," 2 5/8" x 1" x 3/16". Two tones, tin lithograph. (#16) *15-20*

"Down River Federal Savings." 2" x 7/8" x 1 1/4". (#17) *2-5*

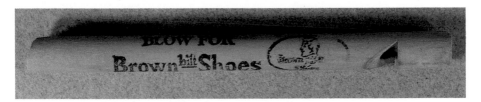

"Blow For Brown bilt Shoes For all the Family." This wonderful old wooden whistle was given out as an advertisement in 1917. 5" x 1/2". (#19) *25-35*

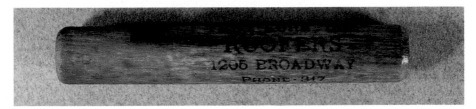

"THEO KUHN INC. ROOFERS 1205 BROADWAY, Phone - 317." Made of wood, 3" x 1/2". This is one of the whistles that you want to look for; it is very hard to find. Note that the phone number has only three numbers, and that 1205 Broadway may not be in New York City. (#20) *30-40*

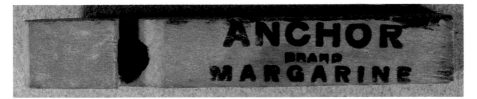

"ANCHOR BRAND MARGARINE," 3 1/2" x 1/2" x 5/16". Made of wood. (#21) *25-35*

Trix, 4" x 1" x 1/4". Plays three tones, made of plastic in the U.S.A. (#18) *15-20*

"I Am Blowing For Rosebud Creamery's Creme-De-Chocolate Drink, Can't Be Beat. Telephone Melrose 2684. Still Independent," 6 5/8" x 3/4". Made of paper and tin in Germany during the 1920s. (#22) 25-30

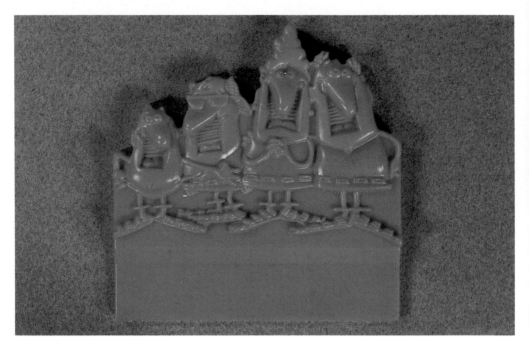

Whistle with four tones, 3 3/4" x 3 5/8" x 3/8". Made by L.C.E. Inc. in China, 1992. (#23) 2-4

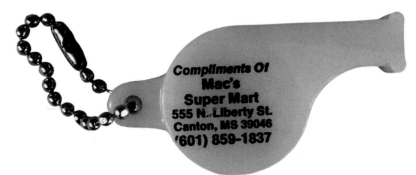

"Compliments of Mac's...," 2 1/2" x 1 1/4" x 7/8". Glows in the dark. (#24)

8-10

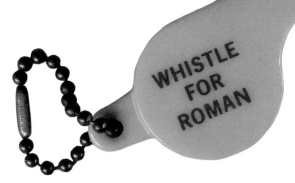

"Whistle For Roman" from Roman
Laundry Detergent, 2 1/2" x
1 1/4" x 7/8". Made of plastic. (#25) *15-20*

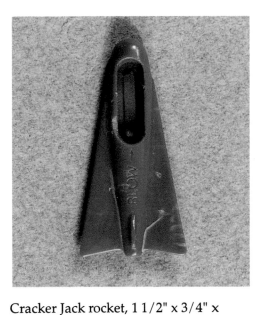

Cracker Jack Ocarina, 1 5/8" x 7/8" x
3/16". Made of hard plastic in the U.S.A.
Comes in assorted colors. (#26) *8-10*

Cracker Jack rocket, 1 1/2" x 3/4" x
1/8". Made of variegated hard plastic.
(#27) *8-10*

Cracker Jack boy on one side, "The
Cracker Jack Co." on the other side,
1 5/8" x 3/4" x 1/4". Comes in assorted
colors. (#28) *8-10*

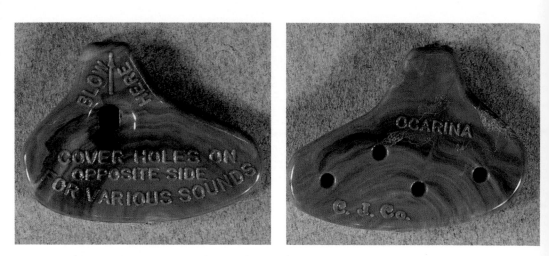

Cracker Jack Ocarina, 1 5/8" x 7/8" x 3/16". Made of variegated hard plastic, older than the item shown in #26. Made in the U.S.A. Comes in assorted colors. (#29) *10-20*

Cracker Jack whistle with two tones, 1 5/8" x 7/8" x 1/8". Made of plastic. (#30) *10-15*

Cracker Jack whistle with two tones, marked "C. J. Co." 2 1/2" x 7/8" x 1/8", made of plastic. (#31) *10-15*

"The C.J. Co." whistle, two tones, 1 5/8" x 7/8" x 1/8". Made of plastic. (#32) *10-15*

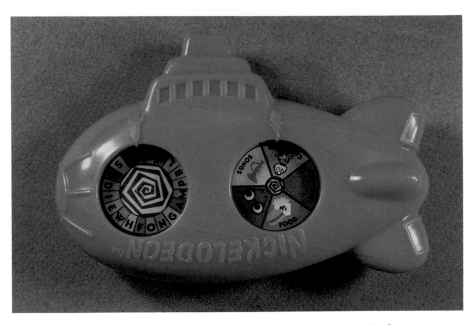

"Nickelodeon," 5 1/4" x 3 1/2" x 1 3/8". Made in China in 1992 for McDonald's Corporation. (#33) 2-4

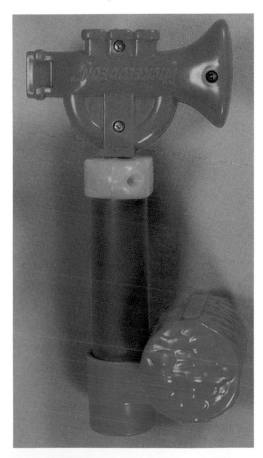

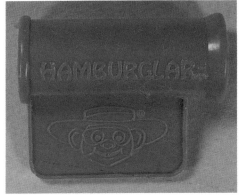

"Hamburglar" turbo siren, 1 7/8" x 1 1/2" x 1 1/2". Made in West Germany for McDonald's Corporation in 1986. (#34) 3-8

"Nickelodeon" squirter and whistle, marked "CW," made in China for McDonald's Corp. in 1992. (#35) 2-4

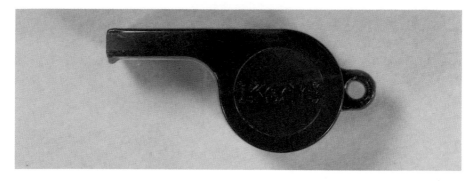

"Keds," 2 1/8" x 1" x 3/4". (#36) *10 - 15*

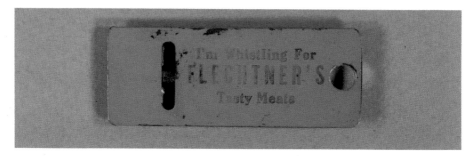

"I'm whistling for FLECHTNER'S Tasty Meats," two tones, 2 5/8" x 1" x 3/16". (#37) *20 - 30*

Horn, 4 1/2" x 1 1/4" x 1 3/8". Made of plastic for McDonald's Corporation in 1986. (#38) *3 - 5*

Airplane Whistles

Turbo Prop whistle with orange wings and a yellow bottom. Comes in assorted colors. Wing span 4", made in West Germany before 1990. If you blow on the tail, the propellers turn and the whistle makes a siren sound. (#39) 3-5

Turbo Prop whistle with blue wings and a yellow bottom. Comes in assorted colors. Wing span 4", made in Germany after 1990. If you blow on the tail, the propellers turn and the whistle makes a siren sound. (#40) 1-2

Blow on the end and the propellor will spin. 3 1/4" x 2 1/4" x 1", made of hard plastic. Comes in assorted colors. (#41) 15-20

Blow on the end to make it whistle. 3" x 2" x 1", made of hard plastic. Comes in assorted colors. (#42) 10-15

Tin lithograph, 1 3/4" x 1 1/2" x 1/4". Made in Japan. (#43) 15-20

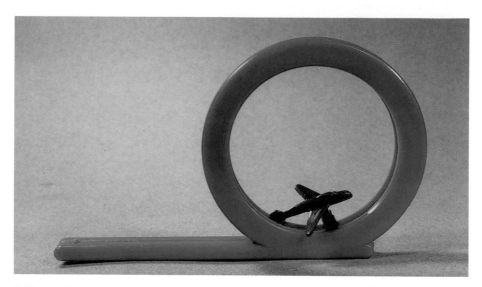

A 'Loop the Airplane' whistle. If you blow on the end, the whistle sounds and the airplane spins in the loop. The harder you blow the faster the airplane goes. Made by the Elmar company during the late 1950s, hard plastic in assorted colors. (#44) 25-35

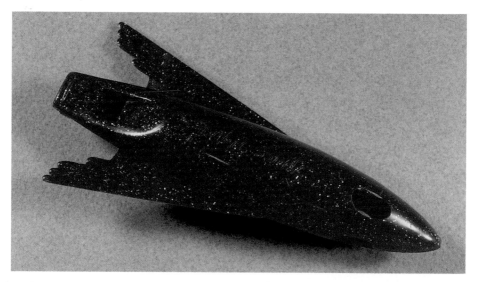

Rocket Space Signal, 5" x 2 1/2" x 1". Made during the 1950s by the Spec-Toy company in the U.S.A. Comes in hard plastic. (#45) 25-35

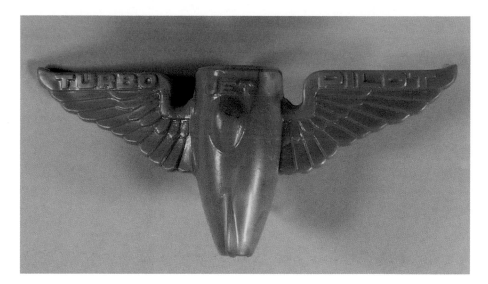

Turbo Jet Pilot with turbo whistle, 3 1/2" x 1 1/2" x 3/4". Made of hard plastic. (#46) 25-35

Rocket, 3 3/4" x 1" x 3/4". Made of variegated hard plastic. Made by Trophy Products during the 1940s. (#47) 25-35

Rocket, 3 3/4" x 1" x 3/4". Made of hard plastic in different colors. Made by Trophy Products in the late 1940s to 1950s. (#48) 25-35

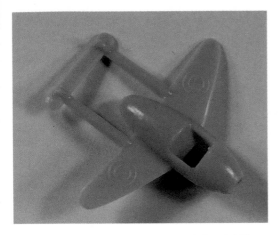

Jet airplane, 1 3/4" x 1 7/8" x 1/4". Made of hard plastic in Hong Kong. (#49) 5-10

Tin lithograph, 1 3/8" x 1 1/4" x 1/4". Made in Japan. (#50) 5-10

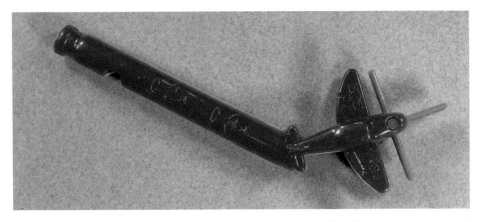

Blow on the end and the propellor will spin. Made of hard plastic in assorted colors, 5" long. (#51) 10-15

Rocket ring, 1 1/4" x 3/8". Made in Japan. (#53) 15-25

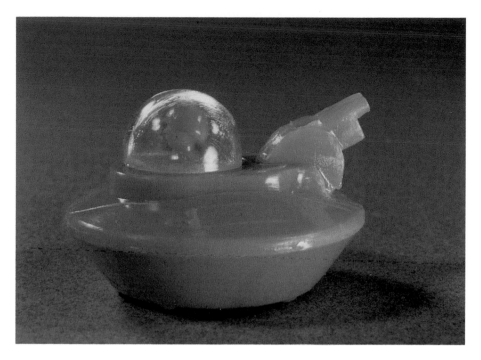

Flying saucer, whistle, and pencil sharpener. Made of hard plastic,
1 3/4" x 1 1/4". Made in Hong Kong. The pencil sharpener is under the
whistle. (#52) *10 - 15*

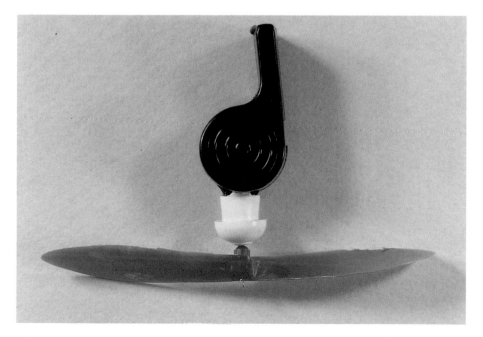

When you blow on the whistle, the 4" propeller spins. (#54) *5 - 10*

Animal Whistles

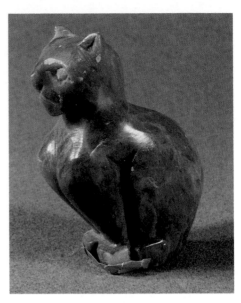

Cat, 2 3/4" x 1 3/4" x 1". Handmade of
soapstone in India. (#55) *10-15*

Mouse with bell, 2 1/8" x 1" x 5/8".
Mouse is plastic, bell is metal. (#57) *1-2*

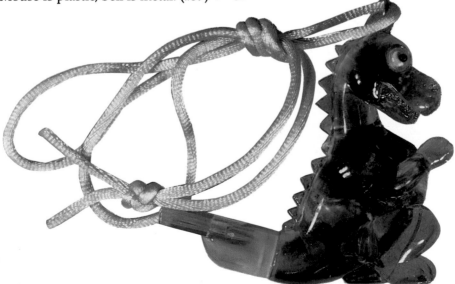

Dragon, 2 1/4" x 2 1/2" x 3/4". Made of plastic in Taiwan, Republic of China.
(#56) *1-2*

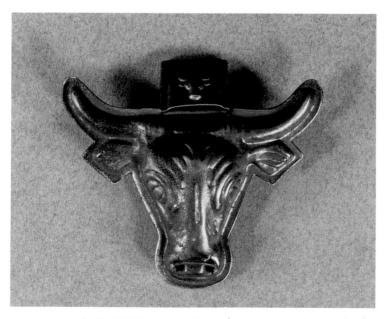

Mickey Mouse bubble pipe and whistle,
4 1/2" x 2" x 1 1/2". Made of hard
plastic by Lido. (#58) *10~15*

Dumbo the elephant, 3" x 1 1/4" x 3/4".
Made of soft vinyl. (#60) *.50~1.00*

Bull, 2 1/2" x 2 1/4" x 1/2". Made of tin
in Japan during the late 1950s. (#59) *15~25*

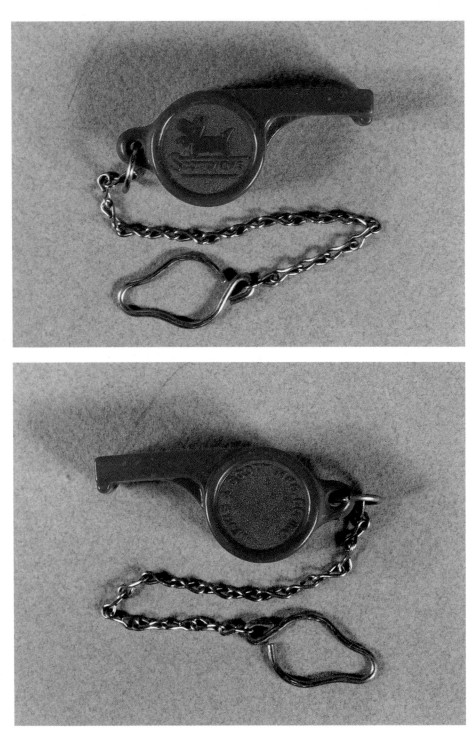

"Scotty Dog," 2 1/2" x 1" x 3/4". Made of hard plastic by Scotty Toys, Lewis & Scott Mfg. Co. (#61) 15-20

Elephant and lion whistles, 1 1/2" x 1" x 3/4". Made of hard plastic in the late 1940s to early 1950s. These were prizes that you could win at a carnival. (#62)

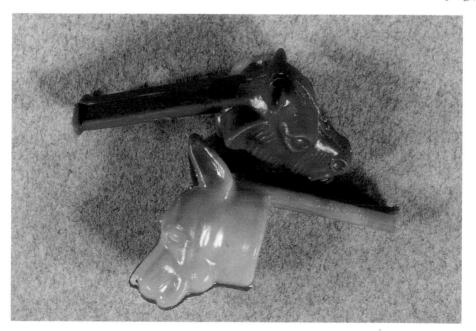

Bull and dog whistles, 1 1/2" x 1" x 3/4". Made of hard plastic in the late 1940s to early 1950s. This was a prize that you could win at a carnival. (#63)

Fish, 3 1/2" x 2" x 1/2". Made of plastic in Hong Kong, marked "No. 635." If you blow on the mouth, the tail will spin. (#64) ⌐⌐∂

Fish, 4" x 1 1/2" x 1". Made of plastic in China, 1994. (#65) ⌐∂

Dragon, 3" x 3 1/2" x 1 1/2". Made in China for Kennedy Peterson in 1994. (#66) ⌐∂

Bird Whistles

Tin lithograph water whistle. To get it to work, take it apart in the center, fill it 3/4 of the way with water, and put it back together. Then blow on the end to make a chirping sound just like a bird. Made in Japan, 3" from the bottom to the top of the stem. A water whistle of this type is rare. (#67) 60-80

Water whistle made of hard plastic. Fill it halfway with water, then blow on the end to make a chirping sound just like a bird. Made in Hong Kong. (#68) 5-10

Water whistle, 2 1/2" x 3/4" x 3". Fill it 3/4 of the way with water, then blow on the end to make a chirping sound just like a bird. Made in the U.S.A. during the early 1950s. Comes in assorted colors. (#69) 15-25

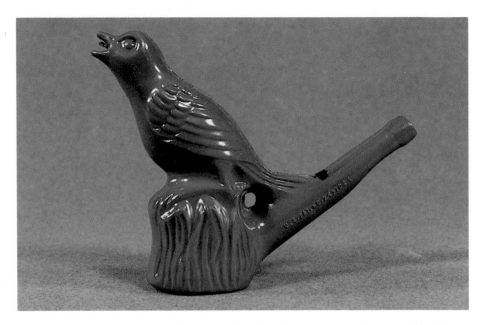

Water whistle, 2 1/2" x 5/8" x 3". Fill it 3/4 of the way with water, then blow on the end to make a chirping sound just like a bird. U.S. Pat. No. 2437024, made in 1949. Comes in assorted colors. (#70) *15-25*

Duck, made of hard plastic, 2" x 1" x 3/4". Made in Hong Kong. (#71) *5-10*

Water whistle, 2 1/2" x 3/4" x 3". Fill it 3/4 of the way with water, then blow on the end to make a chirping sound just like a bird. Made in the U.S.A. during the late 1950s. Comes in assorted colors. (#72) *15-20*

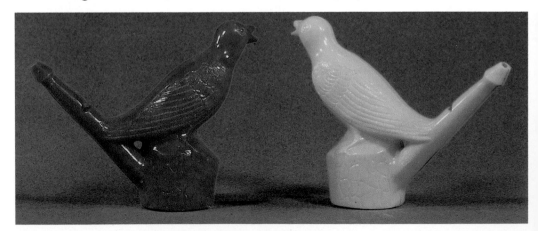

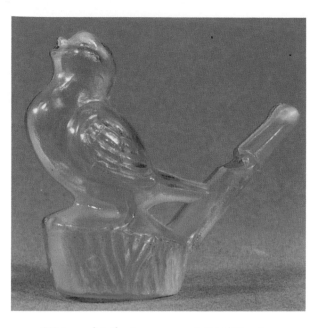

Water whistle, transparent, 2 1/2" x 1 1/4" x 2 1/2". Fill it 3/4 of the way with water, then blow on the end to make a chirping sound just like a bird. Made in Hong Kong in assorted colors. (#73) 5~10

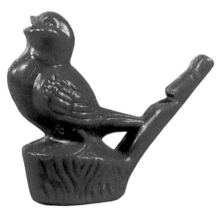

Water whistle, 2" x 2" x 3/4". Fill it 3/4 of the way with water, then blow on the end to make a chirping sound just like a bird. Comes in assorted colors. (#74) .5~10

Water whistle, 1 5/8" x 1 5/8" x 3/4". Fill it 3/4 of the way with water, then blow on the end to make a chirping sound just like a bird. Comes in assorted colors. (#75) 5~10

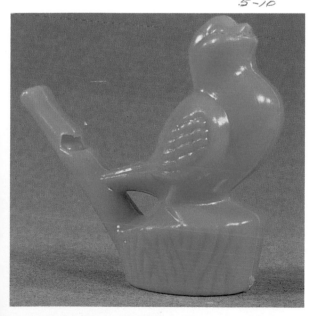

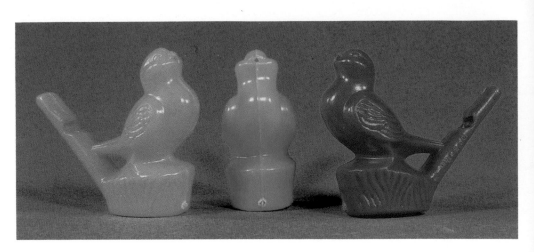

Water whistle, 2 1/4" x 1" x 2 1/2". Fill it 3/4 of the way with water, then blow on the end to make a chirping sound just like a bird. Made in China, marked "501." Comes in assorted colors. (#76) *2 - 3*

Water whistle in variegated plastic, 2 3/4" x 3/4" x 2 3/4". Fill it 3/4 of the way with water, then blow on the end to make a chirping sound just like a bird. Comes in assorted colors. (#77) *2 5 - 3 5*

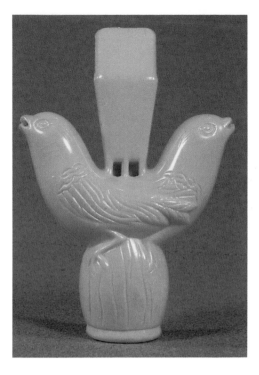

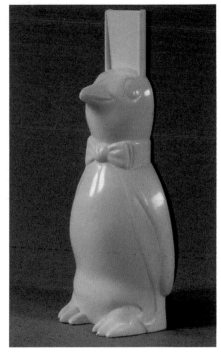

Water whistle, two tones, 3 1/2" x 2 1/2" x 1". Fill it 3/4 of the way with water, then blow on the end to make chirping sounds just like two birds. Comes in assorted colors. (#78) 30-40

Penguin, 5 1/2" x 2 1/4" x 1 1/2". Made of hard plastic. White front with black back. (#79) 20-30

Water whistle made of transparent celluloid, 2 1/8" x 3 1/4" x 3/4". Fill it 3/4 of the way with water, then blow on the end to make a chirping sound just like a bird. Made during the 1940s, hard to find. (#80) 40-60

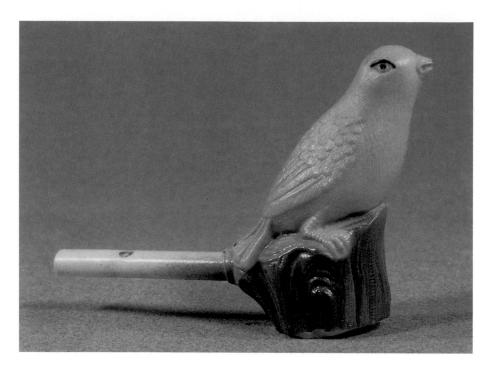

Water whistle made of celluloid, 2 1/8" x 3 1/4" x 3/4". Fill it 3/4 of the way with water, then blow on the end to make a chirping sound just like a bird. Made during the 1940s, hard to find. (#81) 40-60

Donald Duck, 3" x 1 1/2" x 3/4". Made of vinyl. (#82) .50-1.00

'Bird on a bird' water whistle, 3" x 3 1/2" x 1 1/4". Fill it 3/4 of the way with water, then blow on the end to make a chirping sound just like a bird. Made during the 1990s, plastic. (#83) 2-3

Stone bisque, 2 3/4" x 3/4" x 1 1/2". Blow on the tail to whistle. Made in Japan. (#84) 15-25

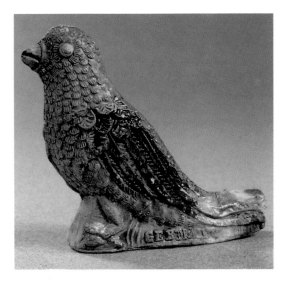

Stone bisque, 2 1/4" x 2 1/4" x 3/4". Blow on the tail to whistle. Made in Germany. (#85) 25-35

Stone bisque, 2 1/2" x 1 1/4" x 1 1/4". Blow on the tail to whistle. Made in Japan. (#86) 15-25

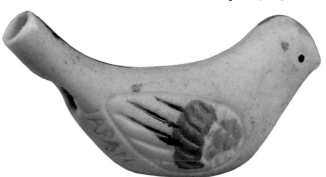

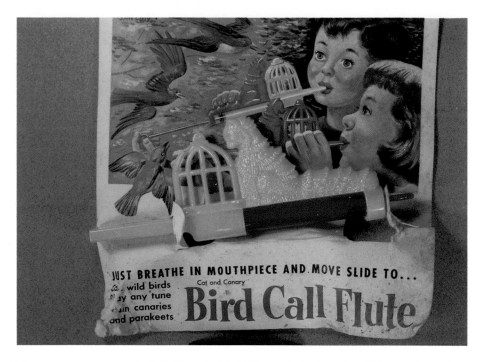

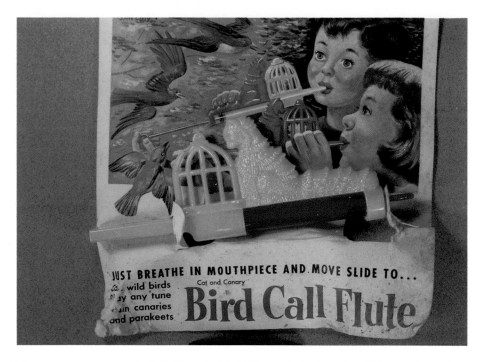

"Cat and Canary Bird Call Flute", 6 3/4" long. Moving the slide rod in and out changes the pitch. It makes a chirping sound like a bird. Manufactured by Bacon Brothers at 177 Milk Street in Boston, Massachussetts, U.S.A. Made of hard plastic in the late 1950s, in assorted colors. (#87) 35-45

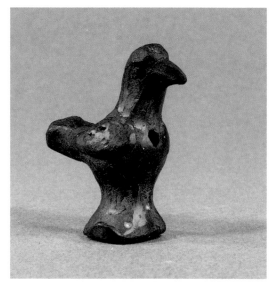

Black ceramic bird, 2" x 1 3/4" x 7/8". Blow on the tail to whistle. (#88) 5-10

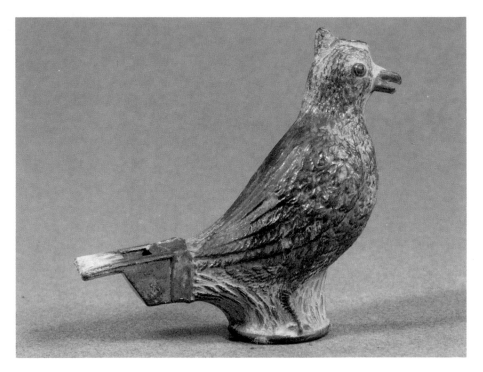

Bird, made of lead, 2 3/4" x 3" x 1 1/8". This whistle should not be played with, since it could give you lead poisoning. Made during the 1930s. Very hard to find. (#89) 55-65

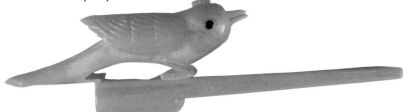

Mechanical bird, 6 1/4" x 1 3/4" x 3/4". When blown on the end, it makes a chirping sound just like a bird, and its beak opens and closes. Made in Hong Kong by CM. (#90) 10-15

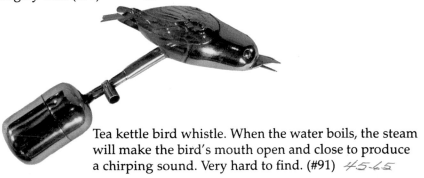

Tea kettle bird whistle. When the water boils, the steam will make the bird's mouth open and close to produce a chirping sound. Very hard to find. (#91) 45-65

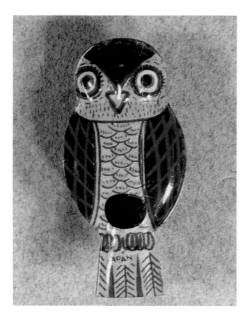

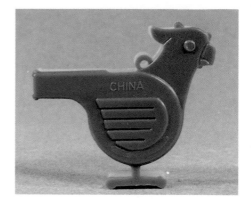

Parrot, plastic, 1 7/8" x 1/12" x 1/2".
Blow on the tail and the head spins.
Assorted colors were made in China
during the 1990s. (#94) 1~2

Owl, tin lithograph, 1 1/2" x 3/4" x
1/4". Made in Japan. Comes in assorted
colors. (#92) 10~15

Owl, 3 1/2" tall. When you blow on the
small tube in the front, the whistle
sounds, the wings flap, and the eyes
spin. Made of hard plastic in assorted
colors. (#93) 10~15

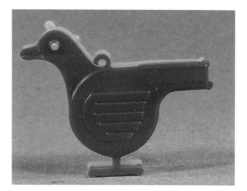

Duck, plastic, 1 7/8" x 1/12" x 1/2".
Blow on the tail and the head spins.
Assorted colors were made in China
during the 1990s. (#95) 1~2

Chicken, plastic, 1 7/8" x 1/12" x 1/2".
Blow on the tail and the head spins.
Assorted colors were made in China
during the 1990s. (#96) 1~2

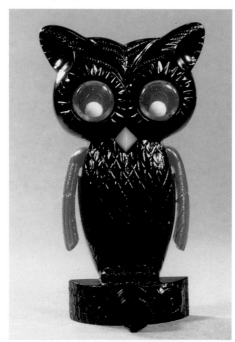

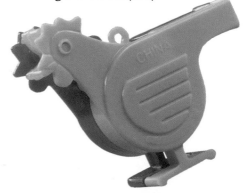

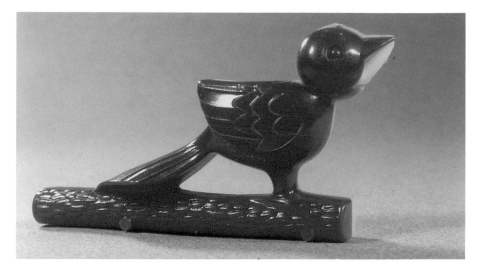

Mechanical, 3 1/4" x 1 3/4" x 3/4". When blown on the end it makes a chirping sound just like a bird, and its beak opens and closes. Made of hard plastic in West Germany. Comes in assorted colors. (#97) *10-15*

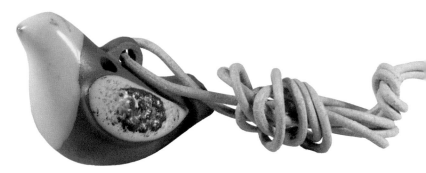

Bird, 1 3/8" x 1 3/4". Handmade ceramic pendant, currently made in Germany. (#98) *10-15*

Wax gum whistle, 3 1/2" x 2 1/2" x 1/2". (#99) *.25*

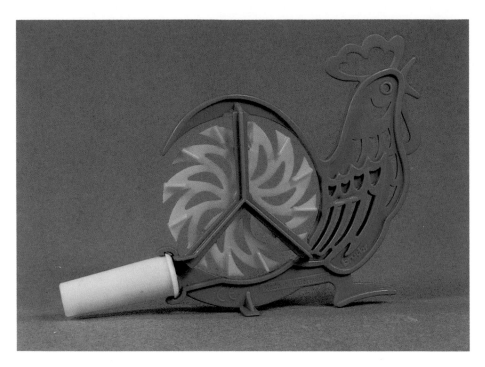

Chicken, 5 1/4" x 3 1/2" x 1/2". Blow on the tail and the center spins. Made in West Germany. (#100) *10 - 15*

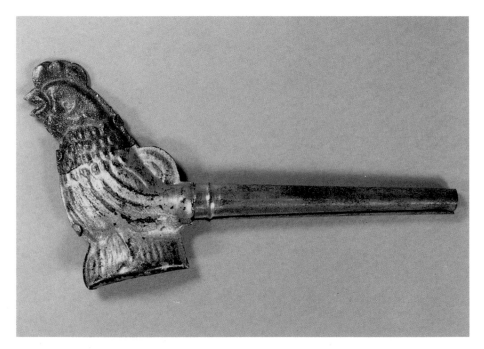

Tin chicken, 4 3/4" x 2 1/2" x 3/8". (#101) *25 - 35*

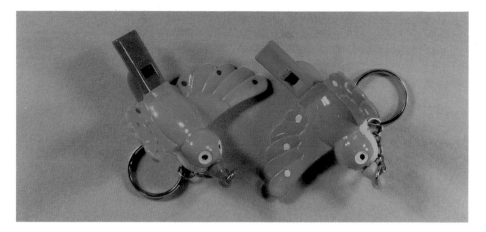

Keychains, 3" x 2 3/4" x 1 1/2". Made in Taiwan during the 1990s. Comes in assorted colors. (#102) . 50 ~ 1.00

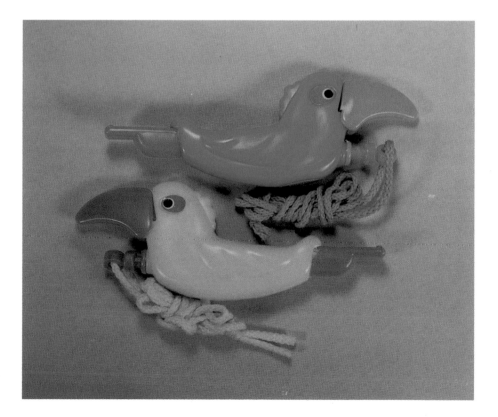

Sliding parrot whistles, 5" x 2" x 5/8". Made during the 1990s by Russ Berrie & Company, Inc. in Taiwan. Comes in assorted colors. (#103) . 50 ~ 1.00

Large 'singing bird' sliding whistle, plastic, 6" x 3 1/4" x 1 1/4". Made in China in 1990s. Comes in assorted colors. (#104) *50 ~ 1.00*

Orange bird, 1 3/4" x 1 3/4". Marked "Walt Disney Pro." Made of hard plastic in Hong Kong. (#105) *15-20*

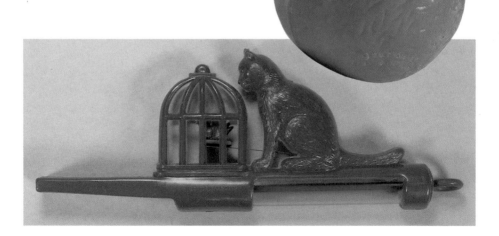

Bird and cat, 6 1/2" x 2 3/8" x 5/8". Made of hard plastic, marked "Western Germany." U.S. patent number 2697298. Note the small cat. (#106) *25-35*

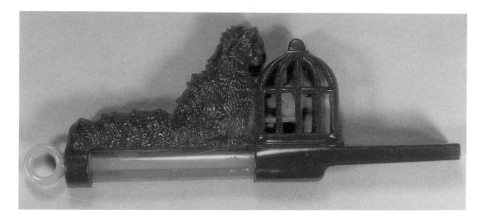

Bird and cat, 6 5/8" x 2 1/2" x 3/4". Made of hard plastic. Note the large cat. (#107) *25-.35*

Black ceramic bird, 2" x 1 1/2" x 1 1/2", with three tones. (#108) *10✓5*

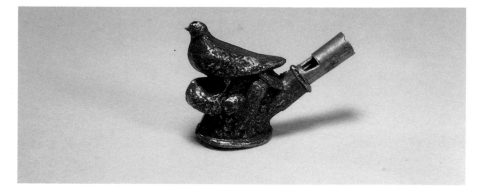

A partridge-shaped water whistle, made of red-painted lead, 2 1/2" x 2" x 3/4". This whistle should not be played with since it could give you lead poisoning. (#109) *30-40*

Boat Whistles

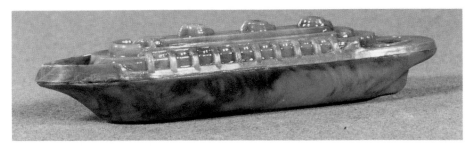

A boat whistle, 4" x 3/4" x 3/4", made of variegated hard plastic. Comes in assorted colors. Made in the U.S.A. (#110) *15-25*

Boat in its original bag, 3 3/4" x 1" x 1", hard plastic. Made in assorted colors in Hong Kong. (#111) *15-25*

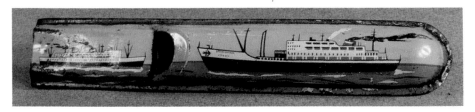

Tin lithograph boat on one side, train on the other, 5 3/4" x 1" x 3/4". Two tones, made in Japan. (#112) *15-25*

"Nautilus 517" tin lithograph submarine, 6 1/2" x 1" x 3/4", made in Japan. Hard to find. (#113) *25-35*

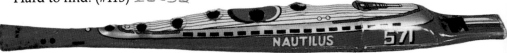

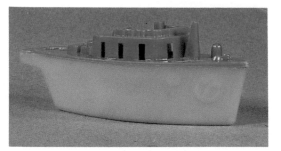

Hard plastic whistle, 4 1/4" x 1 1/2" x 1 1/2". Made in the U.S.A. by Lional (not *Lionel*, the toy train company.) (#114) *10 - 15*

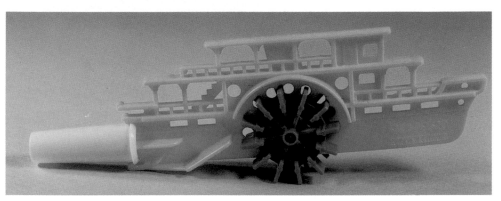

Boat, 6 1/4" x 1 3/4" x 3/4". Blow on the end and the wheels spin. Made by Bruder in West Germany. Comes in assorted colors. (#115) *5 - 10*

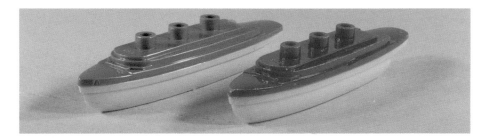

Boat, 3 3/4" x 7/8" x 7/8", made of hard plastic in assorted colors. Made in the U.S.A. (#116) *15 - 20*

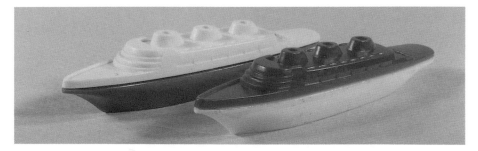

Boat, 4" x 3/4" x 7/8". Made of hard plastic in assorted colors. (#117) *15 - 20*

Boy & Girl Scout Whistles

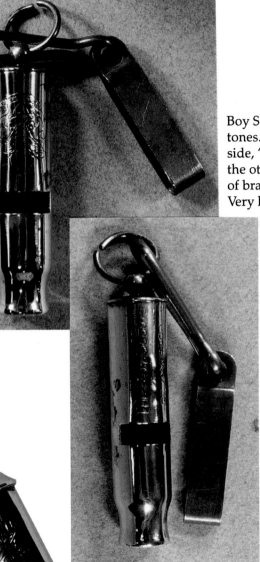

Boy Scout tube-type whistle with two tones. Note the Boy Scout logo on one side, "The Boy Scouts of America" on the other side, and the belt loop. Made of brass during the 1930s and 1940s. Very hard to find. (#118) 60-70

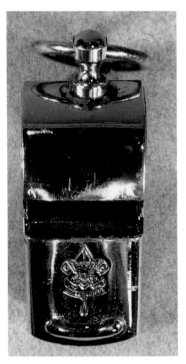

Boy Scout 'police style' whistle in chromed brass, 7/8" x 2 1/4", with the Boy Scout logo and lanyard. Made in 1953. (#119) 15-25

Boy Scout 'English police-style' whistle by Emca, 3 1/8" x 5/8". Made of chromed brass in England. Hard to find. (#121) 20-30

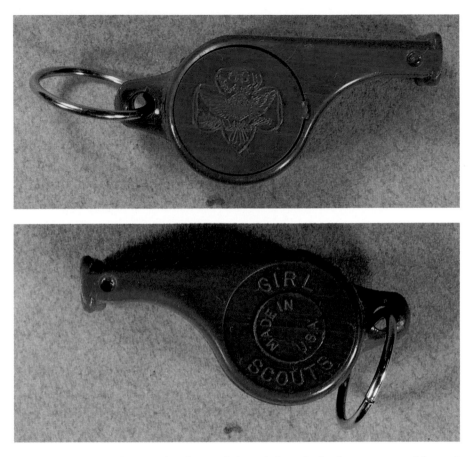

Girl Scout green plastic whistle, 2 1/2"X 7/8", with the logo on one side and "Girl Scouts" on the other. Made in the U.S.A. during the 1950s. *Courtesy of Janet Dundas.* (#120) 15-25

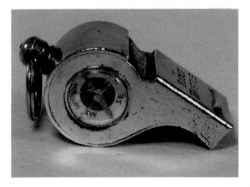

Boy Scout whistle with compass, 2 1/4" x 1" x 7/8". Made in Germany. Very hard to find. (#122) 30-40

Gun Whistles

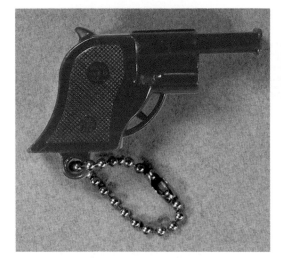

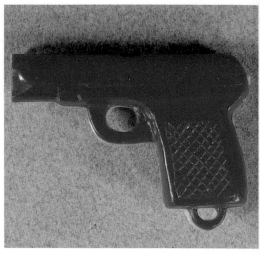

Keychain, made of hard plastic, 2 1/2" x 1 1/4" x 7/8". To whistle, blow on the barrel. By Renwal, marked "No. 45," came in assorted colors. Made in the U.S.A. (#123) *15-20*

Gun-shaped whistle in hard plastic, 2" x 1 1/4" x 3/8". To whistle, blow on the barrel. Made in Hong Kong, marked "No. 508." (#124) *10-15*

"Special Police" whistle, tin lithograph, 3" x 1 3/4" x 3/16". Made in Japan. (#125) *10-20*

Gun with Indian, 4 1/4" x 2 1/2" x 1/8", tin lithograph, two tones. Made in Japan, and registered with the Japanese patent number 399967. (#126) *25-35*

Gun, 2 3/4" x 1 3/8" x 3/4", made of
variegated hard plastic. To whistle, blow
on the barrel. Comes in assorted colors.
Made in the U.S.A. (#127) /5-20

The 'Sergeant' gun whistle, 3 1/2" x 2" x
7/8". To whistle, blow on the handle.
Made of hard plastic. (#128) /5-20

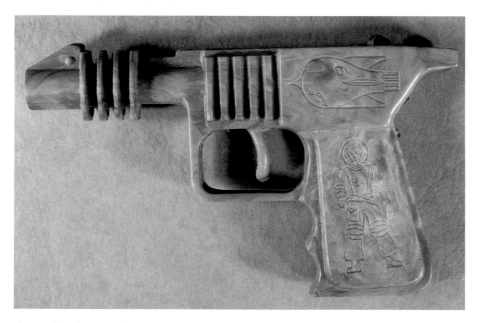

Gun whistle and clicker space gun, made of variegated hard plastic,
4 3/4" x 3" x 3/4". Hard to find. This was a carnival prize from a claw
machine; after trying to line the claw up over the prize you wanted the most,
you would release the claw and try to grab your prize. Of course, the best
things were almost impossible to get! (#130) 35-45

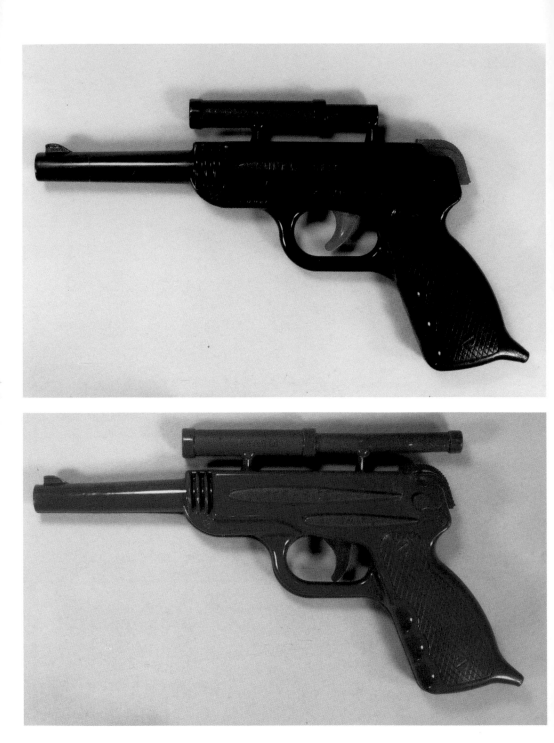

The 'Super-Site' automatic gun whistle, 9" x 5" x 1", in assorted colors. Made in the U.S.A. by Plastic Durable, 21st Century Products, N.Y.C. The whistle is in the tip of the handle. Hard to find. (#129) 25 - .35

Hard Plastic Whistles

A high-wheeler whistle made between 1949 and the early 1950s by Commonwealth Plastic Corp. of Leominster, Massachussetts, U.S.A. Blowing on the whistle makes the plastic balls in the wheels go around. 4 1/8" x 4" x 3/4". Comes in assorted colors. Scarce. (#131) *40-50*

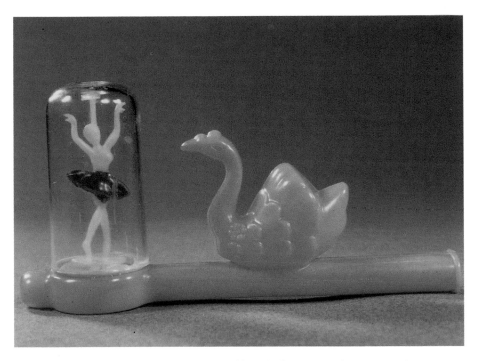

A ballerina and swan whistle made of hard plastic. Made in Hong Kong, marked "No. 2918," came in assorted colors, 1950s. Blow through the opening at the end to hear the whistle and see the ballerina spin. The harder you blow, the faster she will spin. (#132) *20-30*

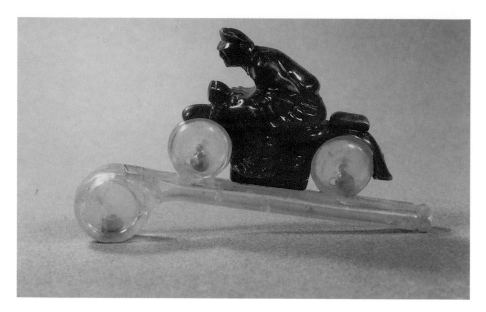

Speed cop, 4 1/8" x 2 5/8" x 1 1/8", red with clear plastic wheels, made between 1949 and the early 1950s by Commonwealth Plastic Corp. of Leominster, Massachussetts, U.S.A. Blowing on the whistle makes the plastic balls in the wheels go around. Comes in assorted colors. Scarce. (#133) 40-50

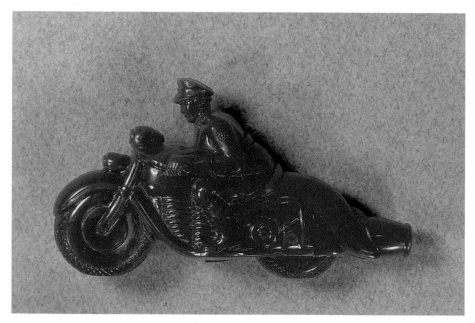

Motorcycle cop, 3 1/2" x 7/8" x 2". Blowing on the turbo-type whistle makes a siren sound. Made by Gerber Plastic Co. USA, 1949 to early 1950s. Made of hard plastic and came in assorted colors. Scarce. (#134) 40-50

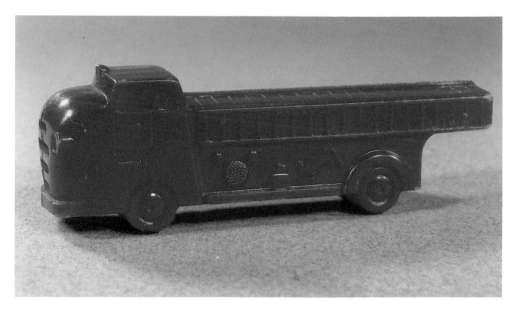

Fire engine, 3" x 1" x 5/8". Blowing on the turbo-type whistle makes a siren sound. Made of hard plastic between the late 1940s and early 1950s. Hard to find. (#135) 20 - 30

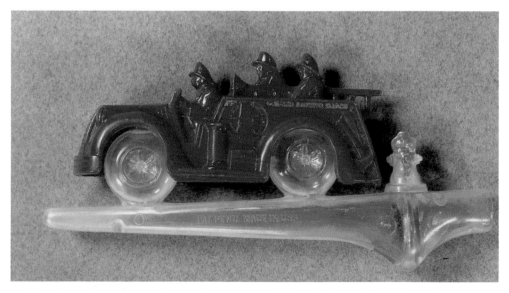

Fire chief siren fire truck, made between 1949 and the early 1950s by Commonwealth Plastic Corp. of Leominster, Massachussetts, U.S.A. Blowing on the whistle makes the plastic balls in the wheels go around. The whistle sound is the turbo-type, which gives a siren sound. Made of hard plastic. Scarce. (#136) 40 - 50

'Teeter-totter' whistle. When you blow on the end, the whistle sounds and the monkeys go up and down. Made of hard plastic. (#137) 15-20

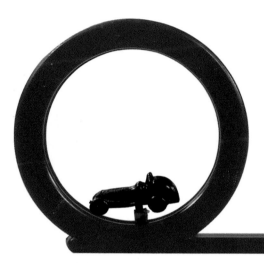

'Loop the car' whistle, in hard plastic. When you blow on the end, the whistle sounds and the race car spins in the loop. The harder you blow the faster the car goes. Made by Elmar U.S.A. in the late 1950s. Comes in assorted colors. (#138) 25-35

Cowboy boot, made of hard plastic, 4" x 2 3/4". When you blow on the toe of the boot, the whistle, sounds and the spur spind. Made in the early 1950s in assorted colors. (#140) 10-15

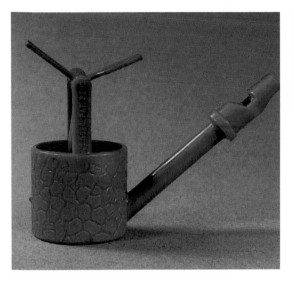

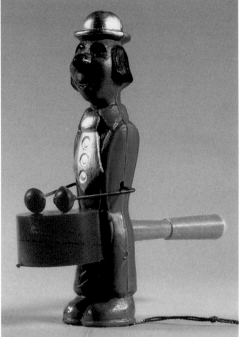

Wishing well, made of hard plastic, 3"
tall. When you blow on the tip, the
whistle sounds and the propellor spins.
Made by Elmar U.S.A. (#139) /5-20

Drummer clown, made of hard plastic,
5 3/4" tall. When you pull on the string,
the clown drums. On the end is the
Clown-shaped bubble pipe and whistle, whistle, so you can whistle and drum at
4 1/4" x 1 1/2" x 1 1/4". (#142) 20-30 the same time. (#141) 35- 45

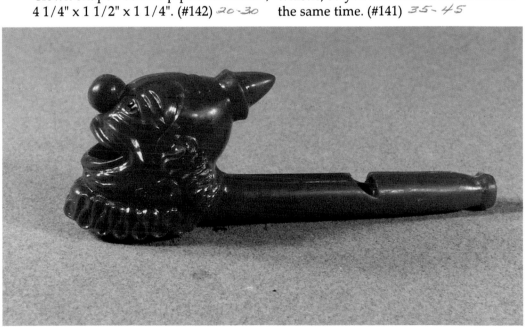

Clown in a pipe, hard plastic, 3 /4" long. Made by Commonwealth Plastic Corp. of Leominster, Massachussetts, U.S.A. between 1949 and the early 1950s. When you blow on the end, the whistle sounds and the clown pops up. (#143) 20-30

"Whistling Billy Bubbles," made by Transogram Co. Inc. at 200 Fifth Ave., New York, NY. Manufactured in the late 1950s to early 1960s. Fill the tub with liquid bubble solution, then blow through the opening in the crown of Billy's hat to whistle; turn the wheel knob to make the bubbles come out. (#144) 30-40

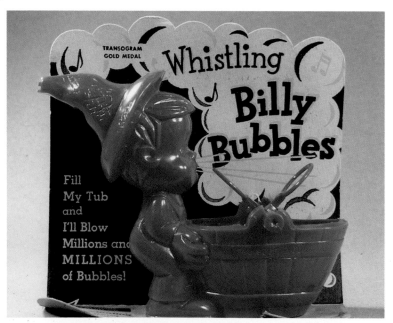

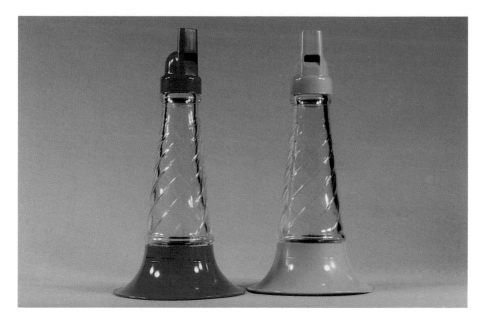

Candy dispensers, 7" tall with 3 3/8" bases, glass and plastic in assorted colors. Made during the 1950s by J.H. Millstein Co. in Jeannette, PA. Hard to find. (#145) 5-10

Banjo, 4" x 1 3/4" x 1/4", made of hard plastic. When you blow on the end, the center will spin. Made in Hong Kong during the 1950s. (#146) 10-15

Plastic tube whistle, variegated, 2 3/4" x 5/8". (#148) *10~15*

Plastic whistle, variegated, 1 7/8" x 1" x 3/4". Made in the U.S.A. (#147) *10~15*

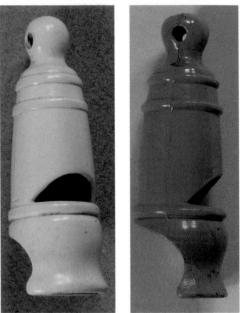

Wide-mouthed plastic whistle, 2 5/8" x 7/8". (#149) *20~25*

"Traffic Ace" wide-mouthed whistle, 2 3/4" x 7/8". Made in Chicago, IL, U.S.A. by Franzite; Pat. No. 1411400. (#150) *20~25*

Keychain, 3 3/8" x 1/2". Two tones, made of plastic. (#151) *5~10*

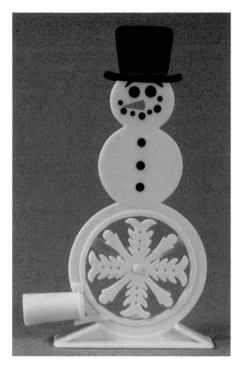

Pan pipes, 4 1/8" x 2 1/2" x 3/4", with four tones. Made by SpectToys in the U.S.A. (#154) *15-25*

Snowman, 6" x 3 1/4" x 3/4". When you blow on the tube, the snowflake spins. Made in China for Applause Inc. during the 1990s, marked "#21697." (#152) *1-3*

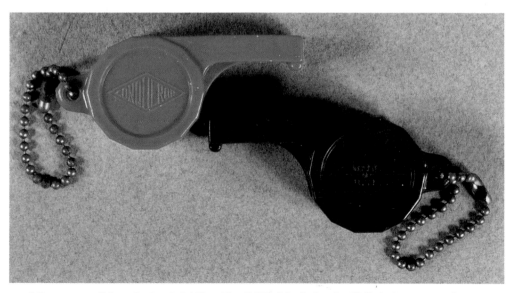

"Conqueror" keychain, 2 1/4" x 1" x 5/8". Made in the U.S.A. in assorted colors. (#153) *10-15*

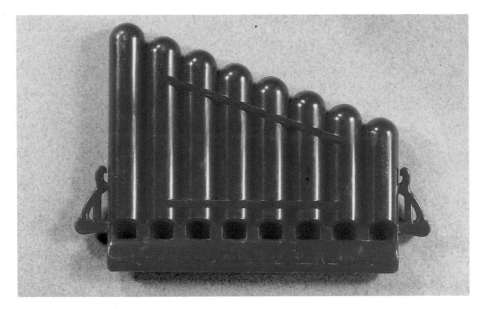

Pan pipes, 5" x 3 1/2" x 1/2", with eight tones. (#155) 20-30

Cowboy clicker and whistle. To whistle, blow on the top of his hat; to work the clicker, push the button on the back. Note that the red and blue cowboy is missing the button; the clicker is broken, so this piece is not worth much. (#156) 10-15

Banana, 4" x 1" x 1". (#157) 3-5

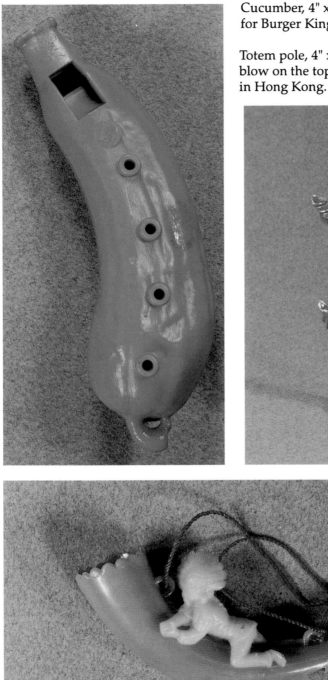

Cucumber, 4" x 1 1/4" x 1 1/4". Made for Burger King. (#158) 2~3

Totem pole, 4" x 2" x 1/2". To whistle, blow on the top of the totem pole. Made in Hong Kong. (#159) 1~2

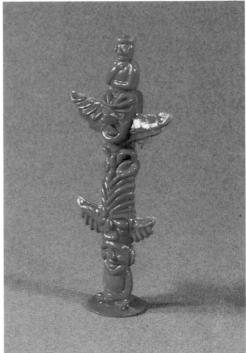

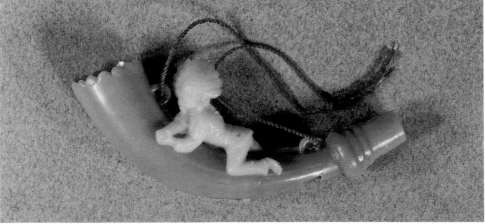

Indian on a powder horn, 3" x 1 1/4" x 5/8". Made in Hong Kong. (#160) 5~10

Clear iridescent whistle, 1 7/8" x 1" x 3/4". Made in China in the late 1980s and 1990s. Comes in assorted colors. (#161) *2-4*

Clear iridescent whistle, 2 1/4" x 1 1/8" x 7/8". Made in China in the late 1980s and 1990s. Comes in assorted colors. (#162) *2-4*

"Best Made," 2 1/2" x 1 1/8" x 7/8". Made in the U.S.A. Comes in assorted colors. (#163) *5-10*

"Blasto," 2 3/8" x 1" x 7/8". Made by PEI in the U.S.A. Comes in assorted colors. Mark on whistle unknown. (#164)

15-20

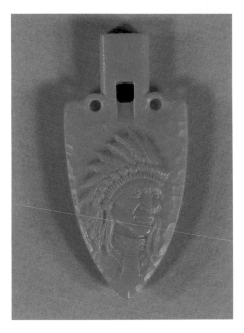

Indian arrowhead, 2 3/4" x 1 1/4" x 1/4". Made by PF Flyer Shoe Co. (#165) .5~10

"Buster Brown Bigfoot" ring, 1 1/4" x 5/8" x 1 1/8", one size fits all, with two tones. Made for Buster Brown. (#166) 5~10

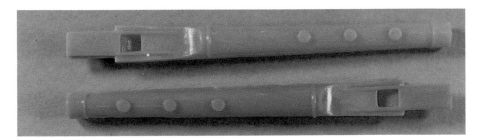

Whistles in flute shapes, 4" x 1/4", one tone. Made in Hong Kong in assorted colors. (#167) 2~4

Three tones, 4 3/8" x 1/2". (#168) 2~4

"Whistle Air," 2 1/2" x 1 1/4" x 7/8". Comes in assorted colors. (#169) 3-6

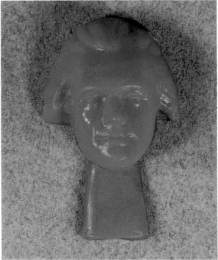

President Jackson, 1 1/2" x 1" x 1/2". Made of hard plastic in Hong Kong. (#171) 10-15

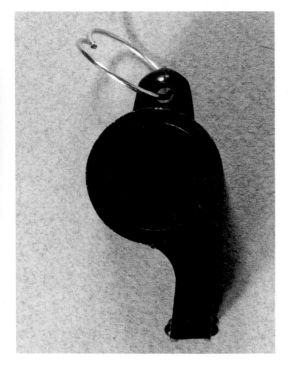

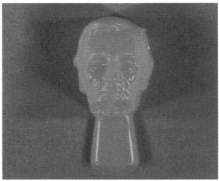

President Lincoln, 1 1/2" x 7/8" x 3/4", made of hard plastic in Hong Kong. (#172) 10-15

Black whistle with a wooden ball inside, 2 1/4" x 1 1/8" x 1". (#170) 10-15

Lip sirens, 2 5/8" x 1 3/4" 7/8". Comes in assorted colors, currently made in Italy. (#173) .25-.50

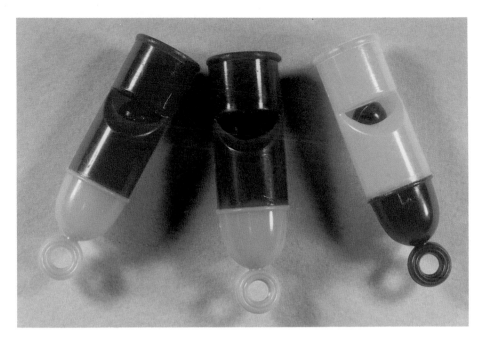

Tube-type whistles, 2 5/8" x 3/4". Currently made in Hong Kong. (#174) .25-.50

Pez makes a wide variety of candy dispensers, but only one Pez whistle. The small tube that can be found in the back of some Pez character heads has a reed in it, which makes the item a horn, not a whistle. This Pez dispenser was made in 1976 in Hong Kong. (#175) 5-10

This Pez dispenser was made in 1990 in China. (#176) *3-5*

Nose Flute. This unique type of whistle was used hundreds of years ago by the Apayaos tribe in Africa as a mating call. How well could he play to hold her attention? To try it yourself, press the nose flute firmly against your nose and mouth (the small part of the flute under your nose, the large part over your mouth). Place your lower lip at the very bottom of the nose flute, and blow only through your nose, making sure there are no air leaks. Your mouth acts as a resonator to change the tone, so change the shape of your mouth to produce different sounds.

Originally made of wood, bone, and ivory, the nose flute appeared in the U.S.A. about 100 years ago, in a tin version. Vinyl versions are still being made today by the Trophy Music Co. in the U.S.A. under Pat. No. 2245432. (#177) *1-2*

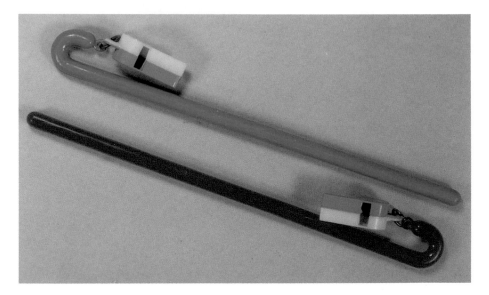

Drink stirrers, 6" x 1/4", hard plastic. If you want another drink, just whistle! The whistles themselves are 1 1/8" x 1/2" x 3/8". (#178) *5~10*

Whistle with two tones, in assorted colors, 2" x 3/4" x 1/8". Made in Hong Kong. (#179) *3~5*

"Blow Other Side," in assorted colors, 1" x 7/8" x 1/4". Made in the U.S.A. (#180) *1~3*

A whistle shaped like a horn, in assorted colors, 4" x 1 3/8" x 1 1/8". Made in Hong Kong. (#181) 5-10

A whistle with an embossed star, 2 1/8" x 1" x 3/4". Made of plastic in the U.S.A. (#185) 1-2

A plastic whistler, 3 3/4" x 1 1/2" x 1/2", made by American Industries, Inc. in 1977. (#182) 5-10

Red, white, and blue whistle, 2 1/8" x 7/8" x 3/4". Made of plastic. (#186) 1-2

"Jumbo," in assorted colors of plastic, 4 1/4" x 2" x 1 1/2". Made by F & H Merchandise Inc. in New York, NY. Comes in assorted colors. (#183) 3~4

A big whistle, measuring 4 1/2" x 2 1/2" x 1 1/4". Made of plastic, in assorted colors. (#184) 2~3

Marked "Perry Whistle," 3 1/2" x 7/8" x 5/8". Made by Hygiene Plastics M/CR in England. (#187) 15-20

Hard plastic keychain, 2 1/2" x 3/4" x 5/8". (#188) 5~10

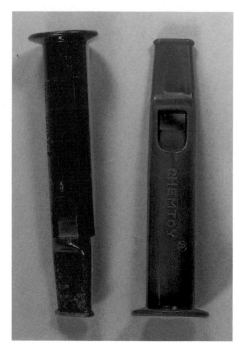

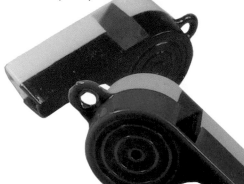

(In blue): marked "Chemtoy," hard plastic, 3 3/4" x 1", made in Hong Kong. (In red): a bubble whistle, hard plastic, 3 3/4" x 1". These seem to be the same whistle, just with different names. (#189) 3~5

Target whistles, 2" x 3/4" x 5/8". Made of plastic in the U.S.A. (#190) 2~3

"Noble Plastic Whistle," 2 1/4" x 1" x 7/8", made by Sportscraft. (#191)
10~15

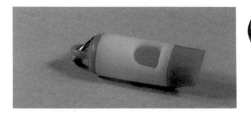

Wee Whistle, 1" x 1/4". Made of plastic in Hong Kong. (#192) *1 - 2*

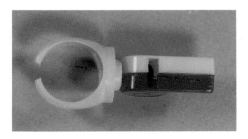

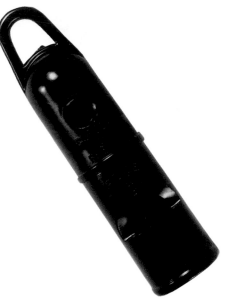

A ring whistle, 1 3/4" x 3/4" x 5/8". Made of plastic. The whistle itself is the same type that is on the #178 drink stirrer (#193) *2 - 3*

Curlew & Peewit # 553 birdcall whistle by Acme, 3" x 3/4". Made of plastic. Currently made in England. (#194) *10 - 15*

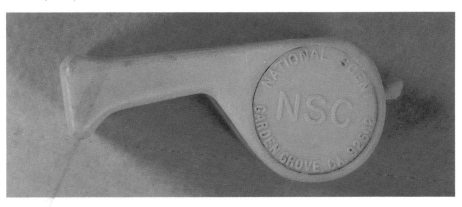

"NSC National Scent Garden Grove" plastic whistle, 1 7/8" x 3/4" x 1 1/8". (#195) *10 - 15*

"Pyro," 2" x 1" x 3/4". Made in the U.S.A. (#196) *10 - 15*

Bell and whistle, 1 3/4" x 3/4" x 5/8", made of plastic. (#197) 2-3

Bell and whistle, 1 3/4" x 3/4" x 5/8", made of plastic. (#197)

Hard plastic, 2 1/8" x 1" x 3/4". Made in the U.S.A. during the 1950s. Comes in assorted colors. (#198) 1-2

Marked "Gold Smith #4" on one side, marked "Stop-it Standard" on the other side, 2 1/4" x 1" x 3/4". Made of Bakelite. (#201) 5-10

A whistle with seven tones, in variegated plastic, 8" x 3/4". Made in Hong Kong, marked "#1443." (#199) *3-5*

"Shield Trumpeter," 2" x 7/8" x 5/8", plastic. Made in Taiwan. (#200) *5√0*

Race cars in an 8" whistle, assorted colors. Blow on the end to make the cars go around and around. Made circa 1970 by Bruder in West Germany. (#202) *20-30*

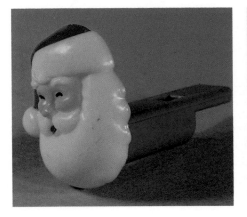

Santa Claus, 2 1/2" x 1 1/2" x 1 1/4". Made of plastic by Amscan in Taiwan. Still made today. (#203) /~2

Christmas light, 2 1/2" x 1 3/4" x 7/8". Made of plastic by Amscan in Taiwan. Still made today. (#205) /~2

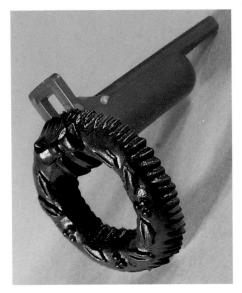

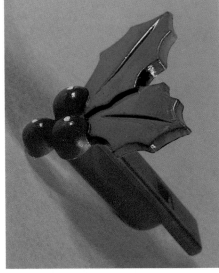

Wreath, 1 7/8" x 1 1/2" x 2 1/2". Made of plastic by Amscan in Taiwan. Still made today. (#204) /~2

Holly, 2 1/4" x 1 3/4" x 1 5/8". Made of plastic by Amscan in Taiwan. Still made today. (#206) /~2

Christmas tree, 2 1/4" x 1 1/4" x 1 1/4". Made of plastic by Amscan in Taiwan. Still made today. (#207) /~2

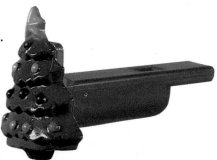

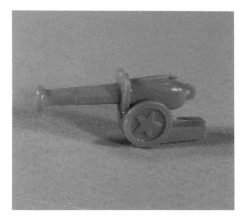

Cannon, 1 7/8" x 3/4" x 7/16". Made of plastic in Hong Kong. (#208) 5-10

Fleers Dubble Bubble Gum whistle, with two tones, 1 1/2" x 1/2". (#209) 5-10

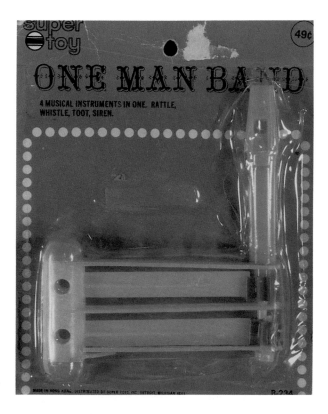

A "One Man Band" with four musical instruments in one: a rattle, a whistle, a toot, and a siren. Made in Hong Kong for Super Toy during the early 1960s. 5 1/4" x 4 3/4" x 3/4", plastic. (#210) 20-30

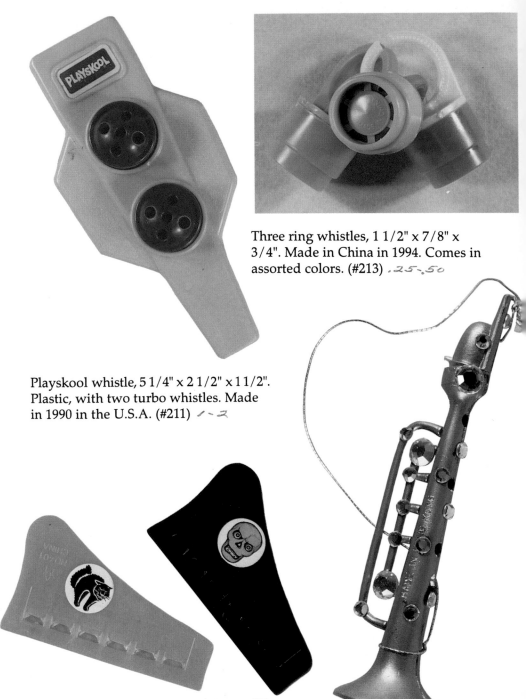

Three ring whistles, 1 1/2" x 7/8" x 3/4". Made in China in 1994. Comes in assorted colors. (#213) .25-.50

Playskool whistle, 5 1/4" x 2 1/2" x 1 1/2". Plastic, with two turbo whistles. Made in 1990 in the U.S.A. (#211) 1-2

A whistle with six tones, 3 1/4" x 1 7/8" x 3/16". Made of plastic in China, marked "No. 401." Made in 1994. Comes in assorted colors. (#212) .25-.50

Christmas trumpet, 4 1/4" x 3/4" x 1". Made in Hong Kong. (#214) 10-15

"Parade Corps Bugle" whistle on its card, 3 1/2" x 5/8", marked "Made in The United States of America." Made during the early 1940s. (#216) 30-40

Christmas saxophone, 3 3/4" x 1 1/2" x 3/4". Made in Hong Kong. (#215) 10-15

Lithograph Whistles

Cowboy, 4 1/2" x 1 3/4" x 1/8", two tones. Made in Japan during the 1950s. (#217) 15-20

Cowboy, 2 1/4" x 3/4" x 1/8", two tones.
Made in Japan during the 1950s. (#219) *10 - 15*

Cowboy, 2 1/4" x 3/4" x 1/8", two tones.
Made in Japan during the 1950s. (#218) *10 - 15*

Cowboy, 2 1/4" x 3/4" x 1/8", two tones.
Made in Japan during the 1950s. (#220)
10 - 15

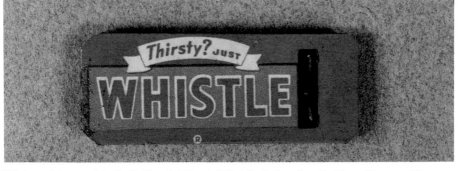

"Thirsty? just whistle." 2" x 3/4" x 1/8". Made by the Golden Orange Refreshment Co. (#221) *10 - 15*

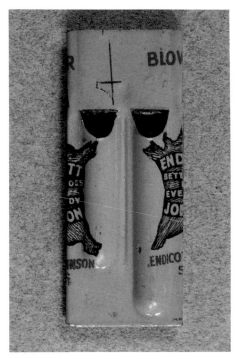

"Blow for real service." 2" x 3/4" x 1/8" with two tones. This example must have been a reject; you can't read the advertisement. (#222) /0~/5

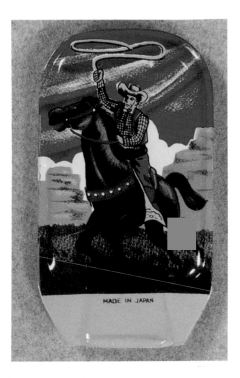

Cowboy, 2 5/8" x 1 1/2" x 3/16". Made in Japan during the 1960s. (#224) /0~/5

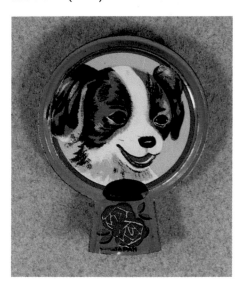

Dog, 1 7/8" x 1 3/8" x 1/4". Made in Japan. (#223) /0~/5

A tin lithograph whistle with three tones, 2 3/4" x 1 1/2" x 1/4". Made in Japan. (#225) /0~/5

Hat, 2 1/2" x 1 5/8" x 5/8". Made in Japan. (#226) 15-20

Boy, 1 5/8" x 3/4" x 3/16". This whistle was made in Japan during the early 1950s, when Japan was making toys out of used cans; note that the inside of this whistle has writing on it. Hard to find. (#227) 15-20

"Close end with fingers," 1 5/8" x 1/2" x 3/8". (#228) 10-?

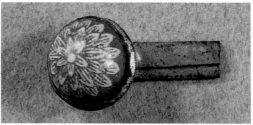

Flower, 1" x 1/2" x 1/2". Made in Japan. (#229) 5-10

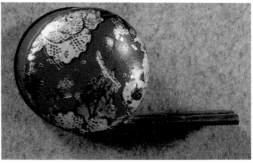

Tin, 1 1/4" x 3/4" x 5/8". Made in Japan. (#230) 5-10

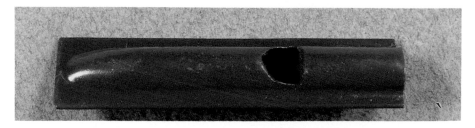

Tin, 2 1/8" x 1/2" x 1/4". Comes in assorted colors. (#231) 5~10

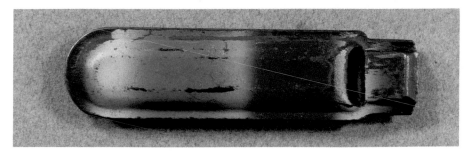

Tin, 3 1/8" x 3/4" x 1/4", with two tones. Made in Japan, in assorted colors. (#232) 5~10

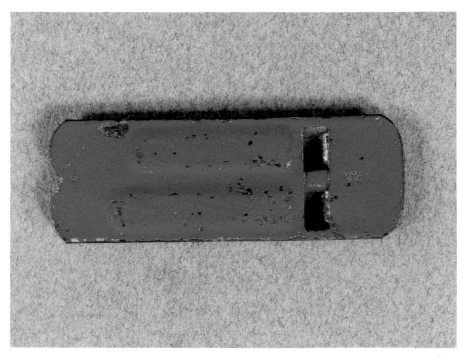

Tin, 2 1/4" x 3/4" x 1/8", two tones. Made in Japan during the early 1950s. The inside of this whistle has writing on it, indicating that it was made from a used can. Hard to find. (#234) 5~10

Tin, 2 1/4" x 3/4" x 1/8", with two tones. Made in Japan, in assorted colors.
(#233) 5-10

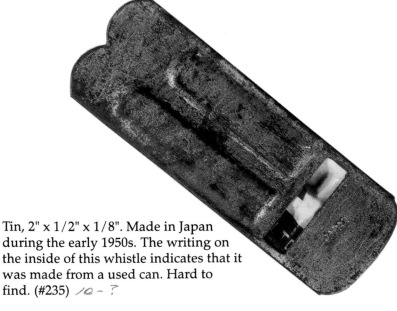

Tin, 2" x 1/2" x 1/8". Made in Japan
during the early 1950s. The writing on
the inside of this whistle indicates that it
was made from a used can. Hard to
find. (#235) 10-?

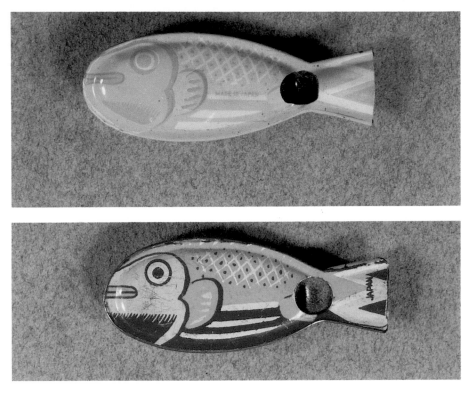

Fish, 1 3/4" x 3/4" x 3/16". Made in Japan in assorted colors. (#236) 5-10

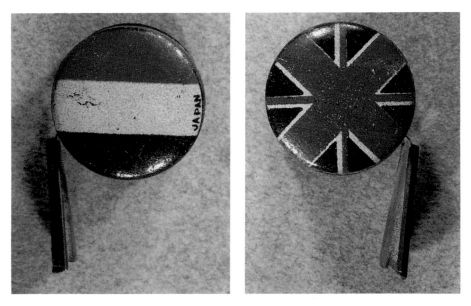

Tin, 1 1/2" x 3/4" x 7/8". Made in Japan. (#237) 15-20

Tin, 1 3/4" x 1/2" x 1/8", with two tones. Made in Japan. (#238) 5-10

Tin, 2 5/8" x 1" x 1/8". Comes in assorted colors. (#239) 5-10

"Sports Whistle," 4" x 3/4" x 1/2", with two tones. Made in Japan. (#240) 10-15

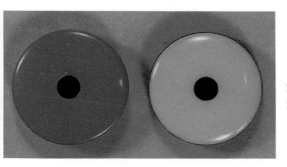

Screamer whistles, 1 1/4" x 1/4". Comes in assorted colors. (#241) *1-2*

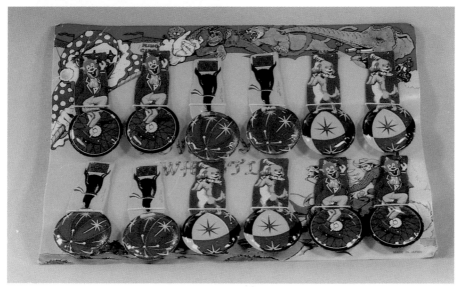

A circus of whistles, each 3 1/4" x 1 1/2" x 3/8". Made in Japan during the early 1950s, when Japan made toys out of used cans. Writing from these original cans appears inside these whistles. It is rare to find them on the card. (#242) *60-80*

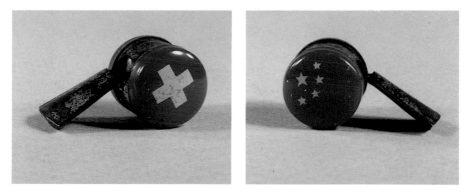

Cross on one side, China's flag on the other side. 1 1/8" x 1/2" x 5/8". Made in China during the 1930s. Hard to find. (#243) *Courtesy of Karen Lee Parrish.*
20-30

Military Whistles

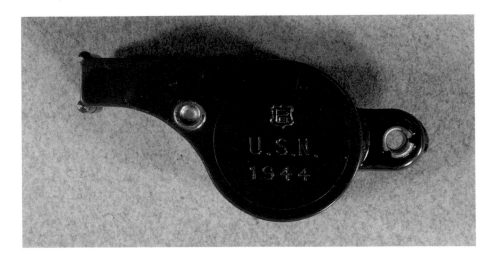

United States Navy, olive drab, marked "U.S.N. 1944" on one side. Made in 1944, during World War II. 7/8" x 2 3/8". (#244) 25-35

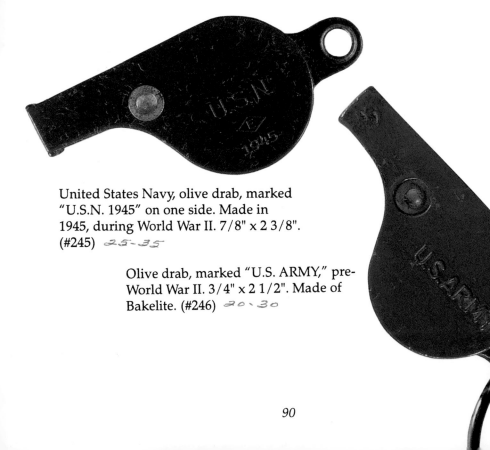

United States Navy, olive drab, marked "U.S.N. 1945" on one side. Made in 1945, during World War II. 7/8" x 2 3/8". (#245) 25-35

Olive drab, marked "U.S. ARMY," pre-World War II. 3/4" x 2 1/2". Made of Bakelite. (#246) 20-30

Olive drab, marked "U.S. ARMY 1943" on one side. Made during World War II. 3/4" x 2 1/2". Made of Bakelite. (#247) 25-35

Olive drab, marked "U.S. G.P.I. 1969" on one side. Made in 1969. (#248) 15-20

Military olive drab, marked "U.S. H.P.I. 1965" on one side. With a military-type chain. Made in 1965. (#249) 15-20

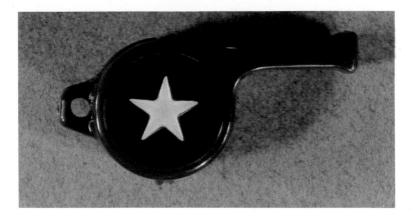

Army-type toy, olive drab with a white star on both sides. 2 1/4" x
3/4". Made of hard plastic. (#250) 5 - 10

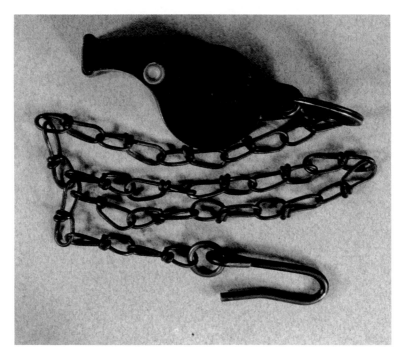

A Bakelite whistle marked "U.S.
ARMY," pre-World War II. 3/4" x
2 1/2". With a chain. (#251) 25 - 30

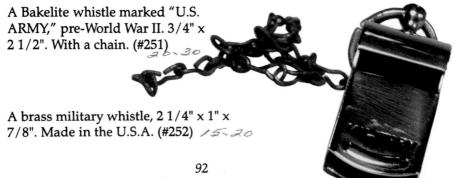

A brass military whistle, 2 1/4" x 1" x
7/8". Made in the U.S.A. (#252) 15 - 20

Movie, Radio, & TV Whistles

Victory whistle, made by Alert in the U.S.A. between 1941 and 1945; also made of variegated plastic. The large V marked on one side stood for "Victory" in World War II; under it is marked "..._" (Morse Code for the letter V). The "..._" also indicates the first four notes of Beethoven's 5th Symphony, which the English played just before their radio programs during World War II. This whistle is hard to find. (#253) 20-30

"Tom Mix Ralston Straight Shooters Signal Arrowhead." A clear lucite arrowhead made in 1949. It features a magnifying glass, a four-tone whistle on one end, and a turbo whistle in the center. (#254) 60-80

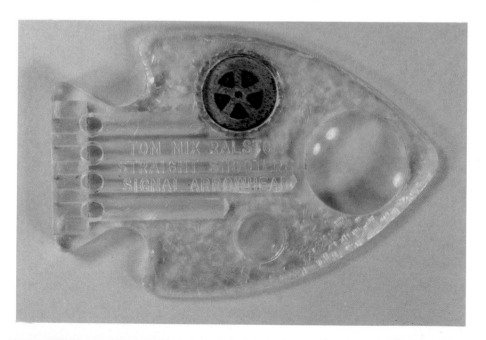

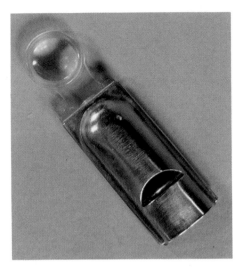

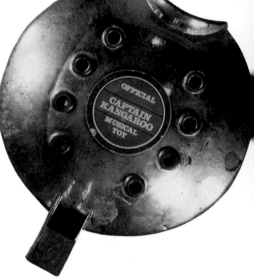

Sky King Secret Signal Scope and Private Code. Only the whistle part of this toy is pictured; the rest is missing. The whistle is made of brass and plastic. Made in 1949. (#255) 20-30

An "Official Captain Kangaroo Musical Toy" flying saucer, 3 3/4" round. Made of plastic. (#256) 15-20

Captain Midnight's 1947 Code-O-Graph whistle and decoder. What was the whistle used for? To call all the kids in the neighborhood to listen to Captain Midnight on the radio. What was the Code-O-Graph used for? At the end of the great crime-stopping program, listeners were given a secret message that could only be solved by using this Code-O-Graph, which came with a code book. Very rare. (#257) 80-90

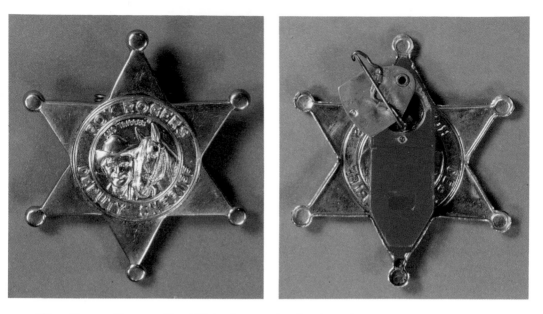

"Roy Rogers Deputy Sheriff" badge, with whistle and secret signaling mirror. Made between the late 1940s and early 1950s. (#258) *80-90*

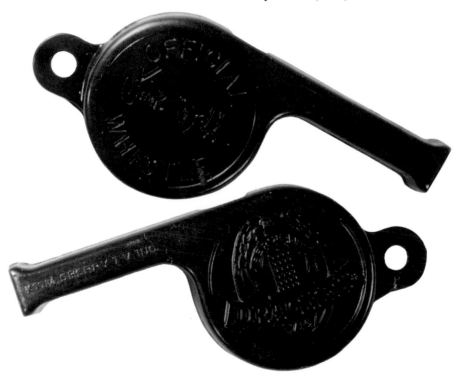

An "Official Jack Webb Whistle" from Dragnet, plastic, 2" x 7/8" x 3/4". Made during the 1960s. (#259) *10-15*

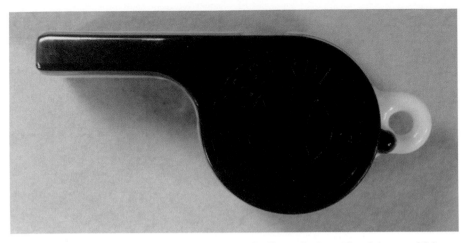

Globetrotters, 2" x 1" x 3/4", with a basketball mark, in red, white, and blue plastic. Made during the 1950s. Hard to find. (#260) *10~15*

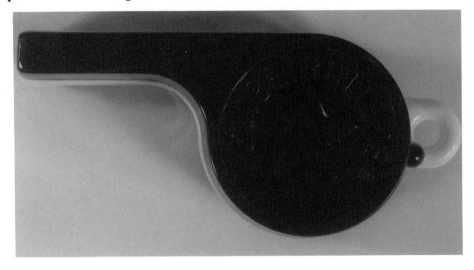

Globetrotters, 2" x 1" x 3/4", with a star mark, in red, white, and blue plastic. Made during the 1950s. Hard to find. (#261) *10~15*

The Lone Ranger, 2" x 1" x 3/4". Made in the U.S.A. (#262) *30.40*

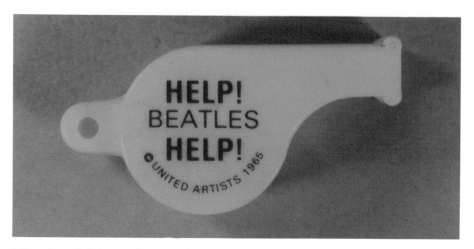

A Beatles whistle, 2 1/2" x 1 1/4" x 7/8". Made of plastic for United Artists in 1965. (#263) 40-60

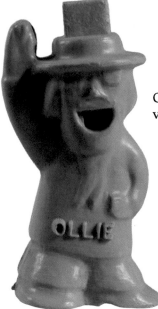

Ollie, 2 3/4" x 1 3/4" x 1". Made of variegated plastic. (#264) 20-30

Snoopy, 3" x 2 1/2" x 1", plastic. Made by United Features Syndicate Inc. between 1958 and 1966. (#265) 50-70

Multiple Tone Whistles

Bugle Boy received an award for the best plastic toy of 1940. They were made by the Chicago Musical Instrument Co., USA.

 There is more than one Bugle Boy whistle to look for. The hardest to find is the first Bugle Boy. This toy sold for 25 cents in 1940. The first and second Bugle Boy are 5 1/4" long. The third and fourth versions are 5 1/8" long. (#266) *100 - 115*

The first Bugle Boy: yellow tip, black body, and yellow bell; marked "Bugle Boy" with no trademark or patent numbers. (#267) *35 - 40*

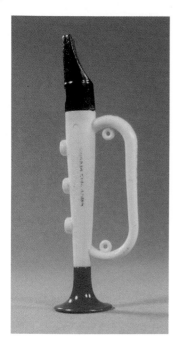

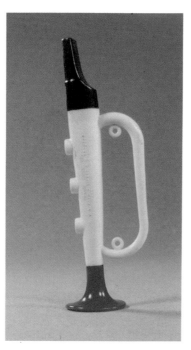

The second Bugle Boy: blue tip, white body, and red bell; marked "Bugle Boy" and "TRADE MARK REC. U.S.PAT. D.115512 OTHER PATS PENDING." (#268) 30-35

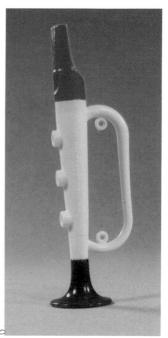

The third Bugle Boy: blue tip, white body, and red bell; marked "Bugle Boy" and "TRADE MARK REC. U.S.PATS. D.115512 & M. 2209427 MADE IN THE U.S.A." (#269) 25-35

The fourth Bugle Boy: red tip, white body, and blue bell; marked "Bugle Boy" and "TRADE MARK REC. U.S.PATS. D.115512 & M. 2209427 MADE IN THE U.S.A." (#270) 20-30

Boy Bugler, 4 1/4" x 1/2". Marked "TRADE MARK REC. U.S.PATS. D.115512 & M. 2209427 MADE IN THE U.S.A." Note same manufacturer as Bugle Boy, also came with a blue tip. Made of hard plastic. (#271) 20-30

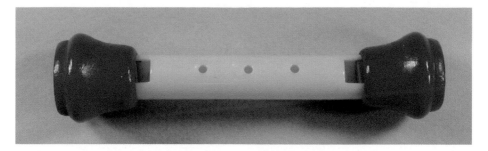

Two whistles in one; this example has wooden ends with a whistle at each end. The center is made of hard plastic with two marbles inside. 5" long with a center diameter of 5/8". (#272) 40-50

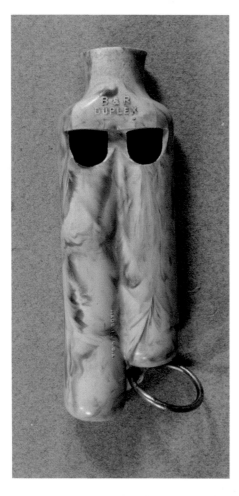

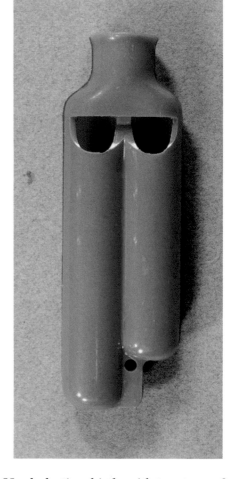

Variegated plastic whistle with two tones, 3 3/4" x 1 1/4" x 5/8". Made by B & R Duplex. (#273) 15-25

Hard plastic whistle with two tones, 3 3/4" x 1 1/4" x 5/8". Comes in assorted colors. (#274) 15-20

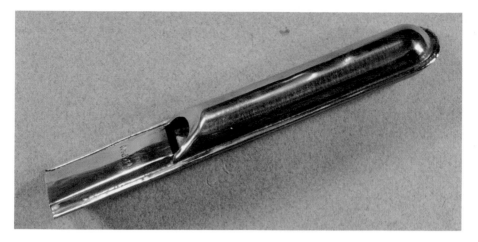

Tin whistle with two tones, 5 5/8" x 1" x 3/4". Made in Japan. (#275) 15-20

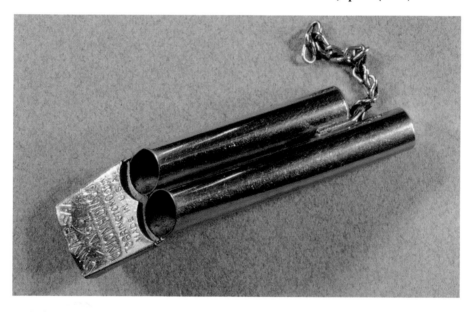

Nickeled brass whistle marked "Universal No. 1 Union HDW Co. Torrington Conn." 3 1/2" x 7/8" x 1/2". Made in the U.S.A. (#276) 20-25

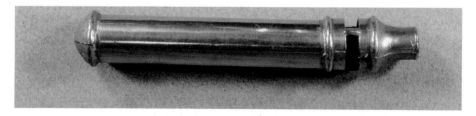

Tube-type whistle with three tones, 4 5/8" x 3/4". Made in Japan. (#277) 10-15

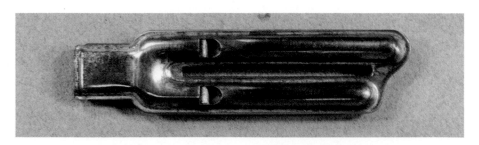

Tin whistle with two tones, 3 1/2" x 7/8" x 1/4". Made in Japan. (#278) *10~15*

Tin whistle with two tones, 2" x 1/2" x 1/2". (#279) *10~15*

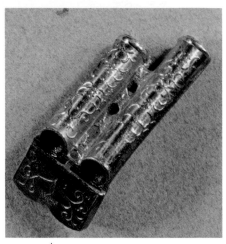

Pot metal whistle with two tones, 2 1/4" x 7/8" x 1/4". Made in Japan. (#280) *10~15*

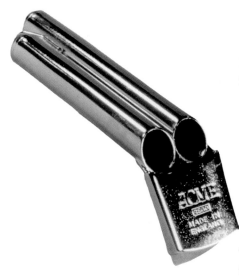

Whistle made with two tones, 3 1/2" x 3/4" x 1/4". Made by Acme in England. Still made today. (#282) *10~15*

Translucent hard plastic whistle with two tones, 4 1/4" x 1 3/8" x 1/2". (#281) *10~15*

Vinyl plastic whistle with two tones, 4" x 1 1/4" x 1/2". Made in China for the Kellogg Co. in 1988. (#283) *3-5*

Hard plastic whistle with two tones, 2 5/8" x 7/8" x 1/8". Made in Hong Kong. (#284) *3-5*

Vinyl plastic whistle with three tones, 3" x 1 3/4" x 1/2". Made in China for the Kellogg Co. in 1988. (#285) *3-5*

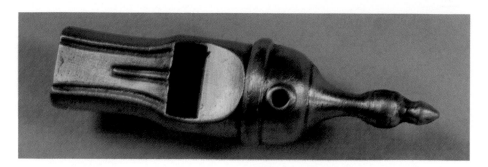

Pot metal whistle with two tones, 3" x 7/8" x 7/8". (#287) *20-30*

Police Whistles

The original two-tone London police whistle was invented by J.L Hudson in 1883. When first tested on Hampstead Heath it could be heard as far as a mile away. It was immediately adopted by the police department as the official Bobby's Whistle, which it remains to this day.

London police whistle made of chromed brass, marked "The Metropolitan, PATENT. J. Hudson & Co. 13. Barr St. Birmingham." 3 1/8" x 5/8" long. Made in 1910. (#288) *80-100*

English-style whistle marked "Regulation Police", 3 1/8" x 5/8". The mouthpiece and end are brass; the center is steel. (#289) *40-60*

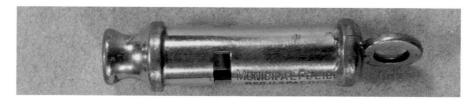

English-style whistle in chromed brass, marked "Municipal Police Reg. U.S. Pat. Off." 1/4" x 3/4" long. Made during the 1920s in the U.S.A. (#290) *40~60*
Courtesy of Mearl and May Noftz.

This English-style whistle should not be played with; it is made of lead, and could give you lead poisoning. 2 5/8" x 1/2". Made in Japan. (#291) *15~20*

English-style whistle made of chromed brass, with a keyring, 2 3/4" x 5/8". Made during the 1980s. (#292) *5~10*

"Traffic Whistle," made of Bakelite, 2 1/4" x 1" x 7/8". Made in Japan during the late 1930s. (#293) *20~30*

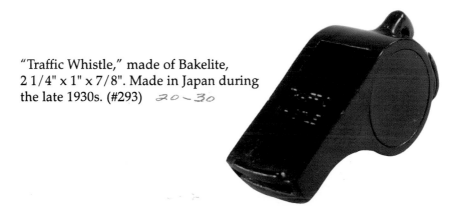

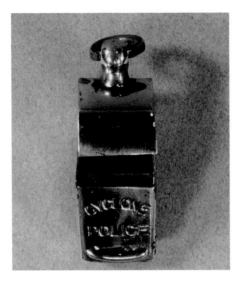

"Cyclone Police" whistle by B & R, 2 1/4" x 1" x 3/4". Made during the 1930s. (#294) 25-35

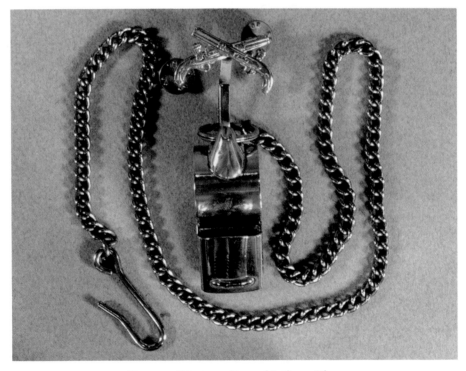

Brass military police whistle, with a chain and crossed brass pistols, 3/4" x 2 1/4". Made in 1959. (#295) 60-80

Sliding Whistles

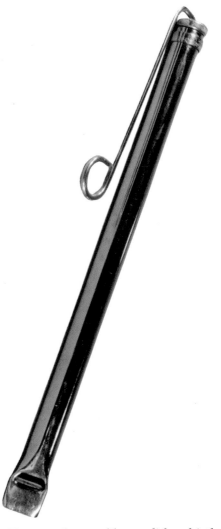

A brass whistle with a dog's head, from Keller, 3 3/8" x 1/4". During the 1930s, you had to send in a Keller's dogfood label and 15 cents to get this whistle. (#296) 60-80

This is a chromed brass slide whistle for use by professionals, 12" x 5/8". Made by Ludwig & Ludwig in Chicago, IL. (#297) 40-60

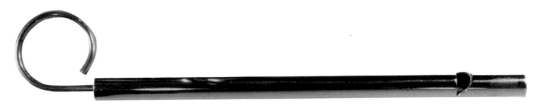

All brass, 7 7/8" x 1/2". (#298) 25-35

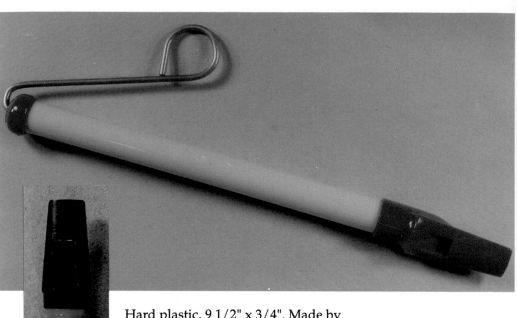

Hard plastic, 9 1/2" x 3/4". Made by Trophy Products in assorted colors. Made in the U.S.A. (#299) *5-10*

Plastic slide whistle, marked "Pito Flauta," 4 3/4" x 1/2". By Sico. (#300) *3-5*

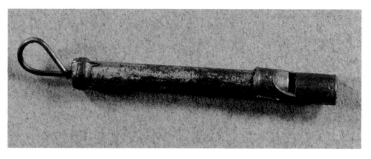

Tin and lead, 2 5/8" x 3/16". This whistle should not be played with, since it could give you lead poisoning. Made in Japan. (#302) *15-20*

Hard plastic, 10" x 3/4". Made by Proll Toys in the U.S.A. Comes in assorted colors. (#301) *2-3*

Tin, 4 3/4" x 1/4". Made in Japan. (#303) *15-20*

Tin lithograph with wooden tip and handle, 10" x 3/4". Made during the 1940s, and marked "Kirchhof, Newark, N.J. U.S.A." Hard to find. (#304) *30-40*

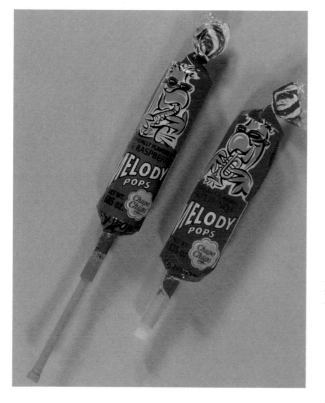

"Melody Pops." You can eat this sliding whistle when you are done playing with it—it's made of candy! Comes with a song sheet so you may play different songs. Made in Spain in 1994, for the Uniconfis Corporation of Atlanta, GA. (#305) *.25*

Parrot, 7 1/2" x 4" x 1 3/8", plastic. Made in Hong Kong for Shelcore Inc., in 1986. (#306) *2-3*

Tin Whistles

Man's head, 1 3/4" x 1 3/8" x 1/4".
(#307) 25-35

Tin tube with lead tip, 3 1/2" x 1/2".
This whistle should not be played with,
since it could give you lead poisoning.
Made in Japan. (#309) 5-10

Tin, 1 3/4" x 7/8" x 1/4". Made in Japan.
(#308) 5-10

Tin tube, 1 1/2" x 1/4". (#311)
5-10

Tin tube with lead tip, 4" x 1/2". This whistle, too, could give you lead poisoning if you play with it. Made in Japan. (#310) *5~10*

Tin marked with a bird of peace, 1 5/8" x 3/4" x 3/4". Made in Japan. (#313) *5~10*

Tin, 1 3/4" x 1/2". (#312) *20~30*

Tin, 1 3/8" x 1 1/4" 1/4". (#314) *3~5*

111

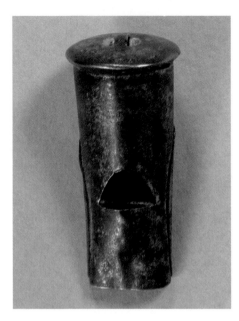

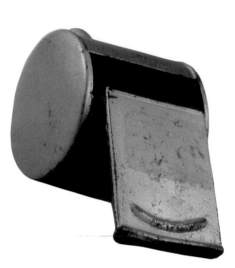

Tin, 1 1/2" x 1/2" x 1/2". (#315) 3-5

Tin, 2 1/4" x 1" x 1". Made in Japan. (#317) 5-15

Tin, 6 1/2" x 1/2". Made in Japan. (#316) 5-15

Tin, 2 1/4" x 1" x 7/8". Marked "Made in Hong Kong," with a lion. (#318) 5-10

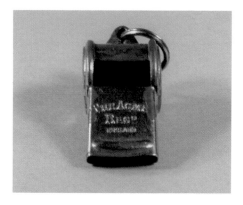

Acme JLH Co., 1 3/4" x 3/4" x 3/4". Made in England during the 1930s. (#319) *15-20*

Tin, 2 3/4" x 1/2". Made in France. (#321) *15-20*

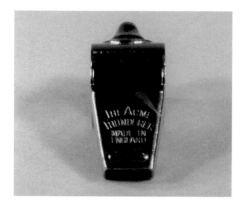

"The Acme Thunderer," 2 1/4" x 1" x 3/4". Made in England in 1994. Acme has made whistles for over 120 years. (#320) *5-10*

The "Siren," 1 3/4" x 3/4". Made in Japan. (#323) *5-10*

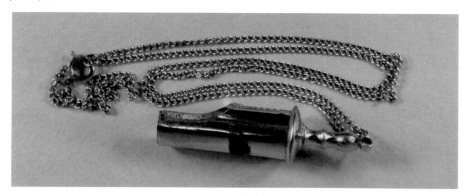

Tin, 2" x 1/2". Made in Germany during the 1940s. (#322) *20-30*

Special Police whistle, 2 1/2" x 1". Made in Japan. (#324) *15-20*

Tin, 2 1/2" x 1" x 1 1/4". Made in Japan. (#327) *10-15*

H.W.T., 1 7/8" x 3/4" x 3/4". Made in Taiwan. (#325) *5-10*

Lead, 2 1/4" x 1" x 1". This whistle should not be played with; it could give you lead poisoning. (#328) *25-35*

Coach's whistle, 1 7/8" x 3/4" x 3/4". Made by the American Whistle Corp. (#326) *5-10*

Marked "Hampion," 1 3/4" x 7/8" x 3/4". Made in China. (#329) 3-5

Tin, 1 1/4" x 3/4" x 1/2". (#332) 5-10

Marked "Made in Hong Kong," with a lion, 2 1/4" x 1" x 7/8". (#330) 3-5

"Crown Continental Metal Whistle," 2" x 3/4" x 3/4". (#333) 3-5

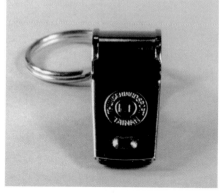

Tin, 1 1/2" x 3/4" x 3/4". (#331) 5-10

"Thunderbird Sport," 1 7/8" x 3/4" x 5/8". Made in Taiwan, by LT. (#334) 3-5

"Screamer Whistle," 1 1/8" x 5/16". (#335) *10 - 15*

Warbler, 1 1/2" x 3/8". (#336) *5 - 8*

Tin, 1 1/4" x 3/4" x 5/8". Made in Japan. (#337) *5 - 10*

Train Whistles

Town and train; blow on the mouth piece to make the train go around and around. Made by D.B.G.M. in West Germany, about 1960. 8" long. (#340) *20 - 30*

Vinyl train, 4" x 1" x 1". Comes in assorted colors. Made in Hong Kong. (#341) *2 - 3*

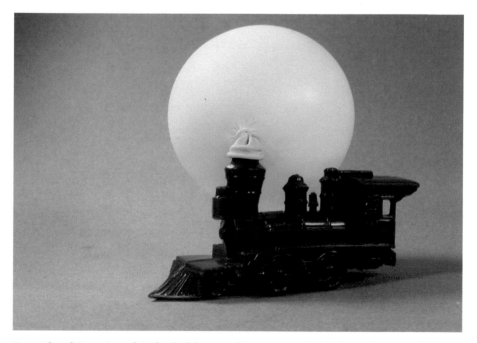

To make this train whistle, hold your finger over the hole at the top of the smoke stack and blow on the mouthpiece at the back of the train. If you inflate a baloon and put it on the opening of the smoke stack, air rushing out of the balloon will make the train whistle and move along the ground. This whistle was a promotion from the Kelloggs Cereal company and the Popsicle company. To get this toy, you had to send in a number of cereal boxtops or posicle wrappers and a small sum of money. Made of hard plastic in assorted colors by Elmar Products, 15 W 24th St., New York 10 NY. 4 3/4" long x 2 1/2" high. (#338) 30-40

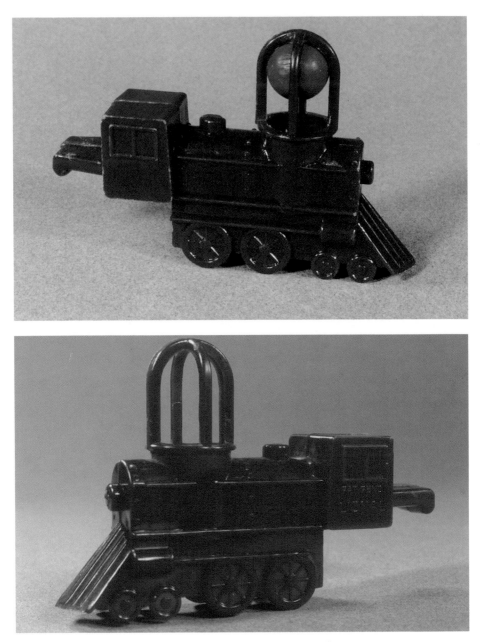

When you blow on the end of this train whistle, a wooden ball rises in the stack. Made in the early 1950s by Lional (not the toy train company "Lionel"). Made of hard plastic, in assorted colors, 3 3/4" long x 2 1/2" high. (#339) *25-35*

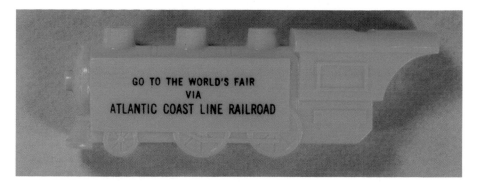

A railroad advertisement reading "Go to the World's Fair via Atlantic Coast Line Railroad." The World's Fair near the Atlantic Coast was the New York World's Fair, held from 1939 to 1940, dating the whistle to those years. Made of hard plastic, 3 1/4" x 3/4". (#342) 30-40

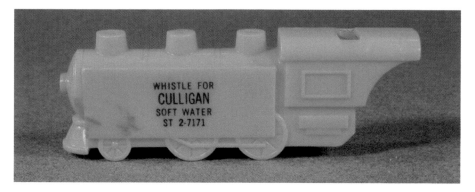

Train-shaped advertisement reading "Whistle for Culligan Soft Water ST 2-7171." The letters "ST" in the phone number indcate that this whistle was made prior to the 1960s. Made of hard plastic, 3 1/4" x 3/4". (#343) 25-30

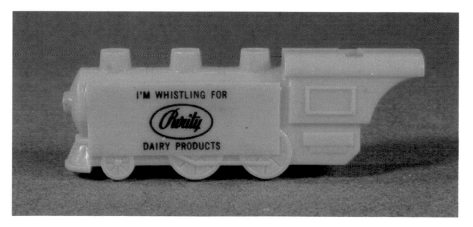

Train-shaped advertisement reading "I'm Whistling For Purity Dairy Products," 3 1/4" x 3/4". Made of hard plastic. (#344) 20-25

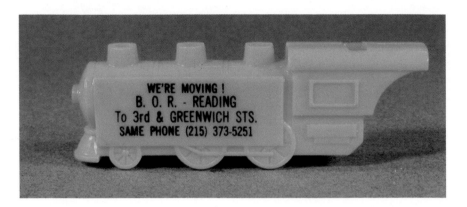

Train-shaped advertisement reading "We're moving! B.O.R.- Reading To 3rd & Greenwich Sts. Same phone (215) 373-5251." Made of hard plastic, 3 1/4" x 3/4". (#345) /5-20

Train, 3" x 5/8" x 1". Made of hard plastic in assorted colors, during the the early 1950s. (#347) 25-30

Train, 3" x 5/8" x 1". Made of Bakelite in assorted colors, during the early 1950s. (#346) 30-40

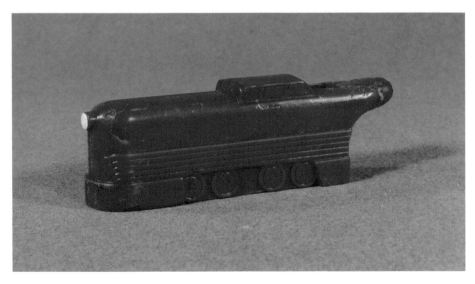

Train, 3" x 5/8" x 1". Made of Bakelite in assorted colors during the the early 1950s. (#348) 25-30

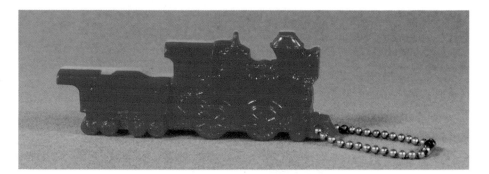

Train keychain, 2 7/8" x 3/8" x 1 1/2". Made of hard plastic by TBC, in assorted colors. (#349) *10~15*

Train with man, made of hard plastic, 4" x 1/2" x 1 1/2". Made in Hong Kong, marked "HP No. 114." (#350) *10~15*

Train "Choo Choo" whistle. Huckleberry Railroad Flint Michigan. Made of hard plastic, 5 1/2" x 1 1/2" x 1", with two tones. Made in Hong Kong. (#351) *20~25*

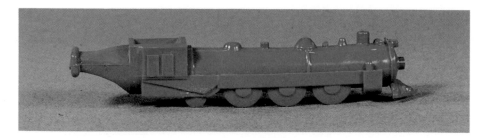

Train by Ardee, 3 3/4" x 1/2" x 1/2", assorted colors. Made in the U.S.A. during the 1960s. (#352) /5-20

Two trains by Lido, 3 3/4" x 1/2" x 1/2", assorted colors. Made in the U.S.A. during the 1950s. (#353) /5-20

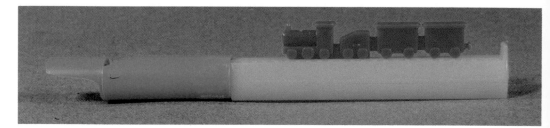

This hard plastic train slides back and forth. Assorted colors made in West Germany during the 1960s. (#354) /0-/5

Train, 4" x 3/4" x 3/4". Came in assorted colors. Made in Hong Kong, marked "No. 294." (#355) /0-/5

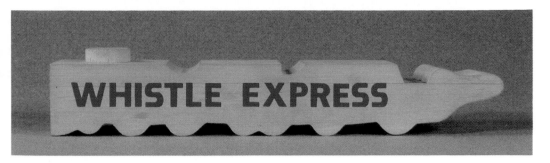

"Whistle Express," 8 1/4" x 1 1/4" x 1 3/8", wooden, with three tones. Made during the 1980s-1990s. (#356) *10 ~ 15*

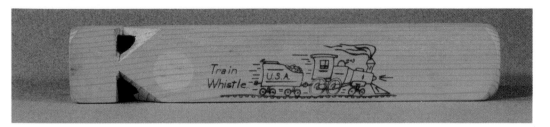

"Train Whistle U.S.A.," 7 7/8" x 1 3/8" x 1 3/8", wooden. Made during the 1980s-1990s. (#357) *10 ~ 15*

Tin lithograph train, 3 3/8" x 1 1/2" x 3/16", with two tones. Made in Japan. (#358) *15 ~ 20*

"Train Sound Whistle," with four tones. Made of plastic in Taiwan in 1994. (#359) *1 ~ 2*

Plastic train by Imperial, 4 3/4" x 3 1/4" x 1". Made in China. (#360) 2 - 5

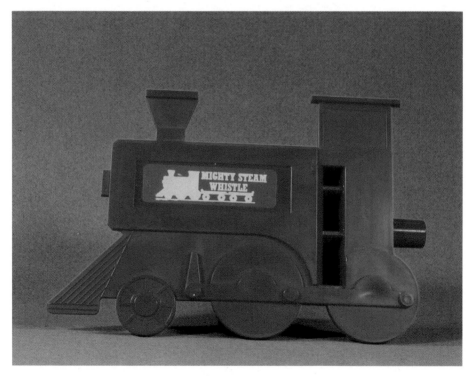

"Mighty Steam Whistle" train, 7" x 4 5/8" x 1", plastic, with three tones.
Made by Sound Toys Unlimited. (#361) 5 - 10

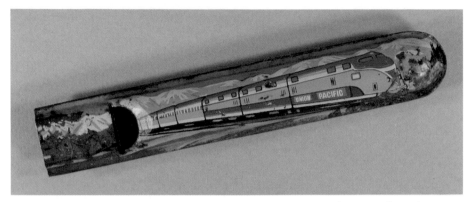

This tin lithograph whistle shows a train on one side, a boat on the other; two tones, 5 3/4" x 1" x 3/4". Made in Japan. A whistle with this much rust is not worth much. (#364)' 5-10

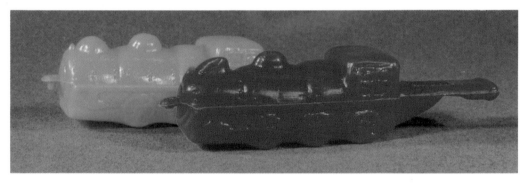

Vinyl, 4" x 1" x 1". Comes in assorted colors. Made in Hong Kong. (#363) 1-2

Vinyl, 4" x 1" x 1". Comes in assorted colors. Made in China. (#362) 1-2

Unusual Whistles

Watch and whistle combination, 2" x 3/4" x 1/4", used by sports personnel. The fifteen-jewel watch was made by Certira in Switzerland during the 1930s, and has a clear back so you can see the movement. Very rare. (#365) *Courtesy of Russ Tasker.* 300-400

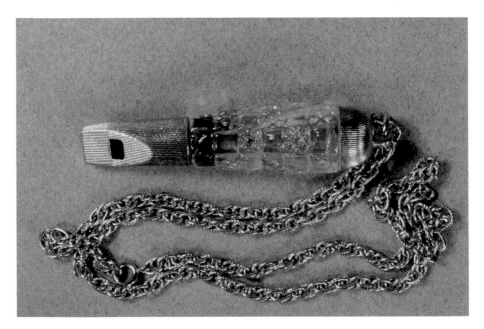

Perfume bottle whistle made by Faberge, 3" x 3/4" x 1/2". Hard to find. (#369) 40-50

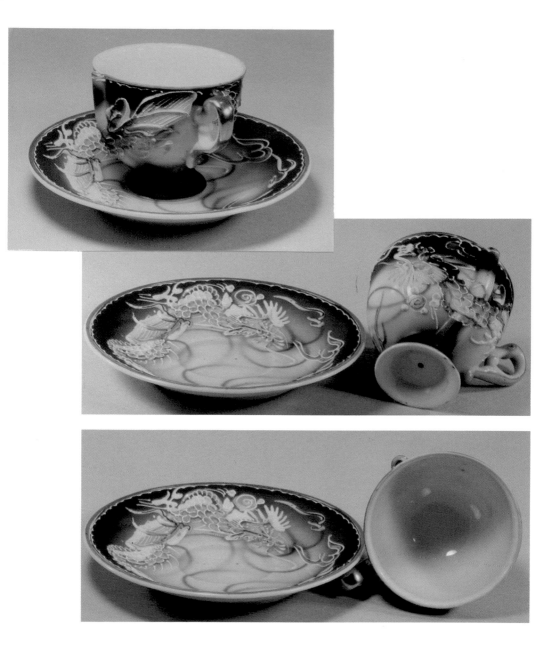

This unique whistle, made in 1950, served as a cup to hold tea. Notice that the cup has one solid bottom, and beneath that a second bottom with a small hole in it. Do you see the channel running up the side of the cup? If a little tea spilled onto the saucer, you could use this channel as a 'straw' to sip it up through the hole in the false bottom of the cup. When you are out of tea, just blow on the edge of the cup (above the channel) and it will sound a whistle to summon for more tea. Very rare. (#366) *Courtesy of Mr. and Mrs. Ward Hoover.* 200 - 300

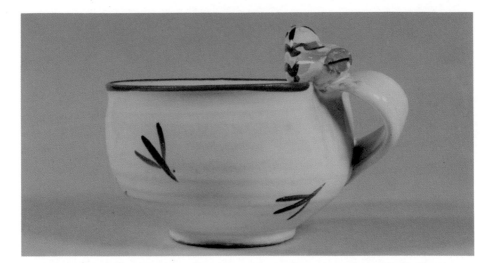

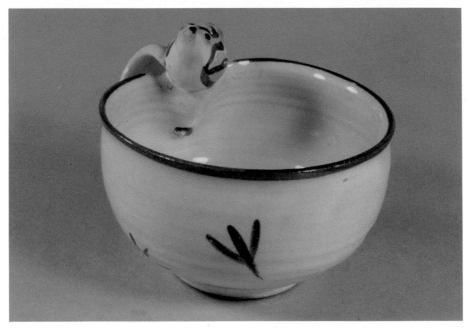

A chirping cup, 3 1/2" high, handmade of stoneware. Fill it with liquid over the level of the inner hole; then blow on the little bird's tail to make a sound like the chirping of a bird. This type of cup goes back some one thousand years, when they were commonly laid in children's graves in Europe. In France, they were used to imitate nightingales in competitions. In England they supposedly kept away evil ghosts. They are still made in Germany today. (#367) 20~30

Earring whistles made of gold, 7/16" x 1/4" x 1/8". Hard to find. (#368) 20~30

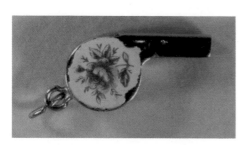

Enameled silver flower, 1" x 7/16 x 1/4".
(#370) 20 - 30

Silver charm, 1/2" x 1/4" x 3/16". (#372)
Courtesy of Sharon Austry. 15-20

Silver charm, 1 1/2" x 1/4" x 1/4".
(#373) *Courtesy of Sharon Austry.* 15-20

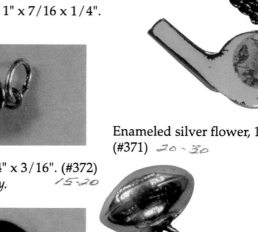

Enameled silver flower, 1" x 7/16 x 1/4".
(#371) 20 - 30

Charm with football, 1 1/4" x 1/4".
Made of brass. (#374) 15-20

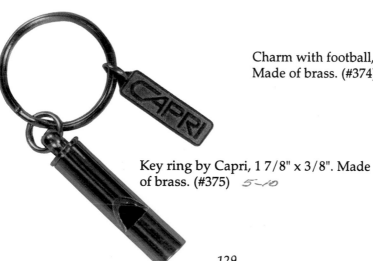

Key ring by Capri, 1 7/8" x 3/8". Made
of brass. (#375) 5-10

Hexagonal silver charm, 1" x 3/16".
(#376) *10~15*

Jeweled, 1 1/2" x 3/4" x 7/8". Made of
brass in Nepal. (#380) *5~10*

Silver charm, 1 1/2" x 1/4" x 1/4".
(#377) *10~15*

Keyring, 1 3/4" x 3/8". Made of brass
and leather. (#378) *5~10*

Jeweled, 1 7/8" x 1/2" x 1/4". Made of
brass. (#381) *10~20*

"Pikes Peak, Alt. 14100 Ft." turbo siren,
3 1/2" x 1 1/8". Made in Japan. (#379)
30~40

Jeweled, 1/3/4" x 1" x 1 1/8". Made of plastic in Taiwan. Still made today. (#382) 2 ~ 3

Jeweled, 1 7/8" x 1" x 1 3/8". Made of metal in Korea. (#383) 3 ~ 5

An English police-type whistle, made of steel and really mink fur, 3" x 5/8". (#384) 20-35

Heart, 1 1/8" x 1/2" x 1/4". Made of painted steel. (#385) 5-10

New York doorman's taxicab whistle, for calling cabs to the front door of a large hotel. Made of chrome steel with three tones, in Germany during the 1960s. (#386) 30-40

Kentucky coal mine whistle, brass, 4 5/8" x 3/4" x 3/4". This type of whistle was used to check for gas before they had electronic detectors. If there was gas in the mine the whistle would not vibrate or warble, and the operator could get the workers out to safety. Very rare. (#387) *80-100*

Bosun mate, 5 1/2" x 1" x 3/4". Made of chromed brass by Penn Mint. This one was used on the USS America CV-66. (#388) *25-35*

This three-tone whistle was used in Germany to announce that trains were about to leave, and that passengers should board. Made of chromed brass in Germany. Hard to find. (#389) *60-70*

Seashell, 3 1/2" long. This real seashell has a turbo or siren whistle at the end. Manufacturer unknown. (#390) *5~10*

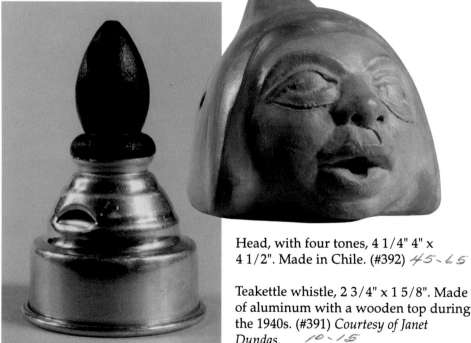

Head, with four tones, 4 1/4" 4" x 4 1/2". Made in Chile. (#392) *45~65*

Teakettle whistle, 2 3/4" x 1 5/8". Made of aluminum with a wooden top during the 1940s. (#391) *Courtesy of Janet Dundas.* *10~15*

Clay, 2" x 1", with four tones. This is a reproduction of a whistle made in the 1400s. (#394) *5~10*

Flashlight, 4" x 1/2". Made of brass. (#396) *15-25*

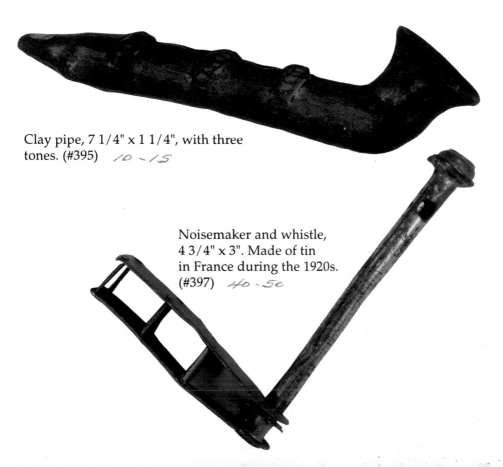

Clay pipe, 7 1/4" x 1 1/4", with three
tones. (#395) *10-15*

Noisemaker and whistle,
4 3/4" x 3". Made of tin
in France during the 1920s.
(#397) *40-50*

Cowboy lasso, 4" x 1 3/4". Made in Japan during the 1950s. (#398) 10~15

A wooden pencil with a plastic whistle, 4 3/4" x 1/4". (#399) 5~10

Horn, 2 3/4" x 7/8", made of real animal horn. From Germany. (#400) 20~30

Horn, 3" x 7/8", made of real animal horn. (#401) 20~30

Horn, 3 1/2" x 1", made of real animal horn. From Germamy. (#402) 20~30

Ceramic, 2" x 7/8" x 3/4". (#403) 3~5

Woman holding a horn, 2 1/4" x 1 3/4" x 3/4", made of brass. (#404) 30~40

Cowboy head, 5 7/8" x 3/4" x 1/2". The hole in the hat is closed. (#405) 10~15

"Survivo"—includes a whistle, match holder, signal mirror, and compass. Still made today. (#406) 15-20

"Ideal"—includes a whistle, match holder, signal mirror, and compass. Precedes the Survivo. Made in Hong Kong. (#407) *Courtesy of Dorothy Schillinger.* 20-25

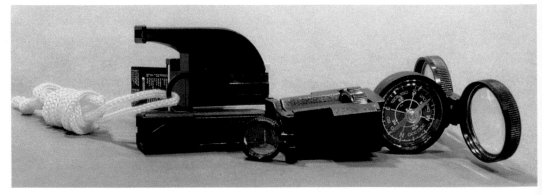

"Super Optic Wonder"—includes a whistle, compass, magnifying glass, observation level, binoculars, heliograph, Morse code chart, and universal sun dial. Made by Navir in Italy. Still made today. (#408) 12-20

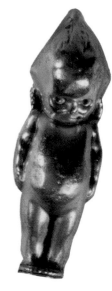

"The Typhoon" by Storm is the world's loudest whistle. Jet airplanes register about 130 decibels; this whistle registers 140 decibels. Made of high impact plastic. The first model was black, then orange was used. Still made today. (#409) 10-12

Ring, turbo siren, 1 1/2" x 3/4" x 3/4". Made of metal. (#410)

Ring, turbo siren, 1 1/2" x 3/4" x 3/4". Made of hard plastic. (#411) 3-5

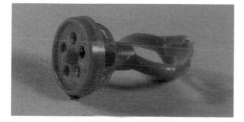

A sterling silver kewpie, 2 1/2" x 3/4" x 3/4", made by P & B. Blow on the feet to make it whistle. Made during the 1920s. (#414) 80-100

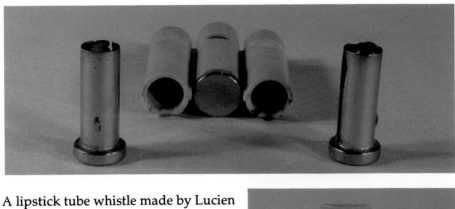

A lipstick tube whistle made by Lucien Lelong of New York and Chicago. This whistle looks like it has three tones, but only the center tube works; the other two contain lipsticks ("Robin Hood Red" and "Sirocco"). Made of variegated plastic. Rare. (#412) *50~60*

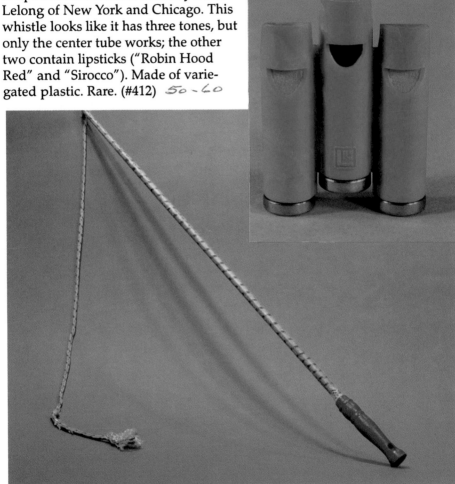

A circus ringmaster's whip with a whistle in the handle, given as a carnival prize. The wooden handle is 4" x 3/4", the stick is 25", and the whip itself is 28"—in total, 57" long. Made during the 1950s. Hard to find. (#413) *35~45*

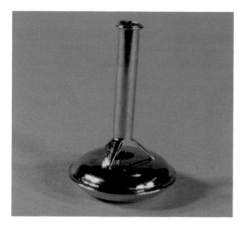

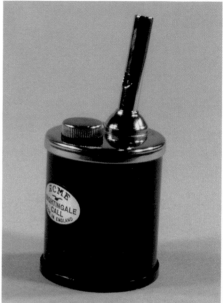

Acme Wind Whistle. Used for theatrical sound effects, this whistle makes a hurricane sound if you blow in the end. 2" long, made of nickel-plated brass. Made by the Acme Whistle Co. in England. Still made today. (#415) *10-15*

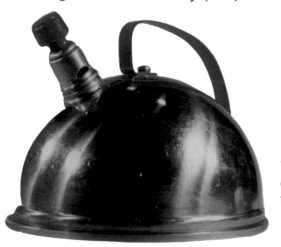

This bird whistle imitates the nightingale's singing voice. Fill with water and blow on the mouthpiece. Acme has made whistles for 120 years. Still made in England. (#416) *20-30*

Whistling teapot, 2 1/2" x 2 3/4", made of aluminum with a wooden tip on the whistle. (#418) *Courtesy of Janet Dundas.* *30-40*

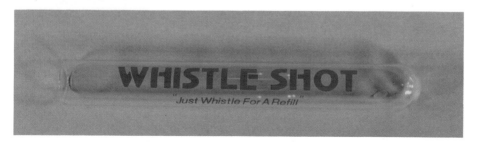

"Whistle Shot / Just Whistle For A Refill." Made of glass, 5" x 5/8". (#417) *30-40*

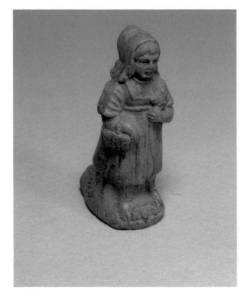 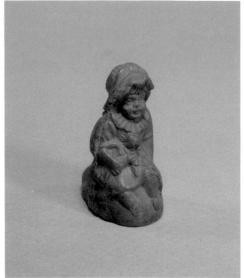

Girl with flowers and a basket, 2 1/4" x 1 1/8" x 7/8". Made of clay. (#419) *25-35*

Girl with a doll, 2" x 1 1/'4" x 1". Made of clay. (#420) *25-35*

Vinyl and Soft Plastic Whistles

Pumpkinhead whistles in assorted colors, 2 3/4" x 1 3/8" x 1 1/4". Made of vinyl in China. Still made today. (#421) *Courtesy of Chelsea Lee Parrish.* *.25*

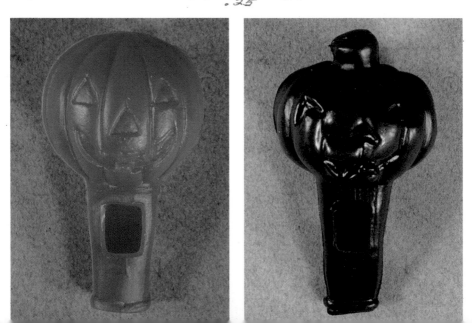

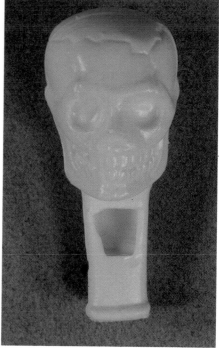

Witch head, 2 7/8" x 1 1/8" x 1 3/8". Made of vinyl in China. Still made today. (#422) *Courtesy of Chelsea Lee Parrish.* •25

Skull, 2 3/4" x 1 1/4" x 1 1/2". Made of vinyl in China. Still made today. (#423) •25 *Courtesy of Chelsea Lee Parrish.*

Head-shaped, 1 3/8" x 1 2" x 3/8". Comes in assorted colors. (#424) •25

Head-shaped, 2 3/8" x 7/8" x 3/4". Made of vinyl in China. Comes in assorted colors. (#425) •25

Soft vinyl, 3" x 1 1/2" x 7/8". Comes in assorted colors. (#428) *1 - 2*

"My-T-Siren" turbo siren, 1 7/8" x 7/8". Made in West Germany. Comes in assorted colors. (#426) *3 - 5*

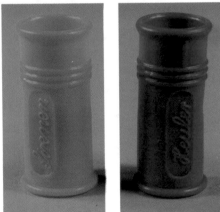

"Heuler" siren, 1 7/8" x 7/8". Made in West Germany. Comes in assorted colors. (#427) *3 - 5*

Arrow-shaped, 2 1/4" x 1 3/3" x 3/8". Made in China, No. 805. Still made today. (#429) *.25*

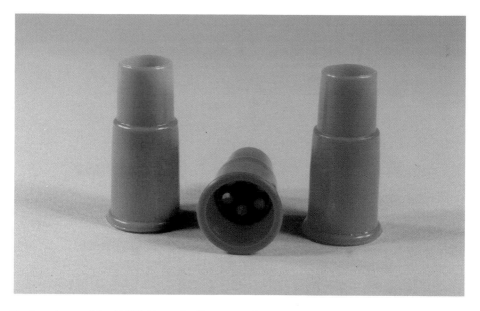

Turbo sirens, 2" x 7/8". Put a balloon on the end, blow it up, and let go. The siren will work as long as the balloon has air in it. Still made in Taiwan. Comes in assorted colors. (#430) .25

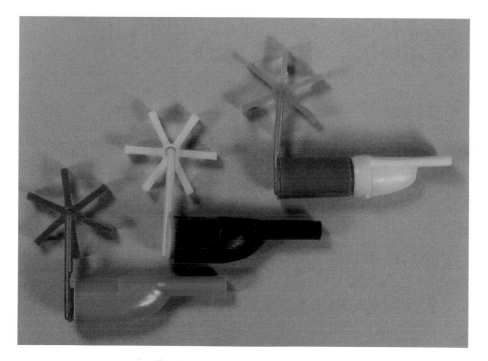

Windmills, 2" x 2 1/8" x 5/8". Blow the whistle to make the windmill spin. Made in Hong Kong. Comes in assorted colors. (#431) .25

Rollerblade necklace with candy, 2 3/4" x 3 1/2" x 1". Made in China for Goodlite Products Inc. of Bedford, TX. Made in 1994. (#432) .75

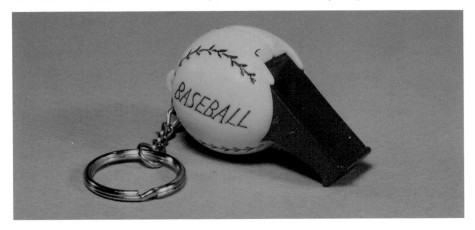

Baseball keychain, 2" x 1 1/8" x 1 1/8". Made in Taiwan in 1994. (#433) 1~2

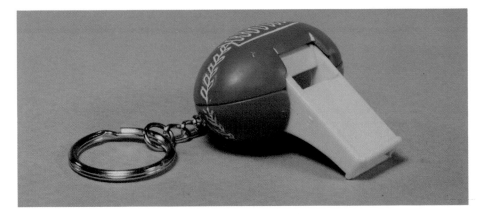

Football keychain, 2" x 1 7/8" x 1 1/8". Made in Taiwan in 1994. (#434) 1~2

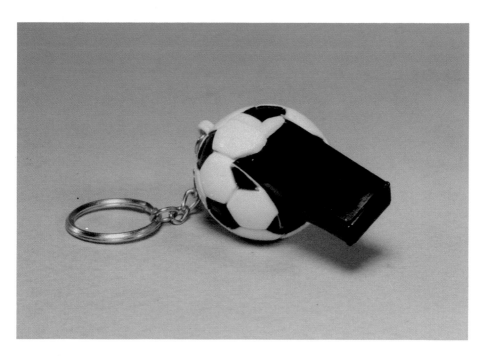

Soccer keychain, 2 3/8" x 1 1/2" x 1 1/2". Made in Taiwan in 1994. (#435) *1~2*

Wooden Whistles

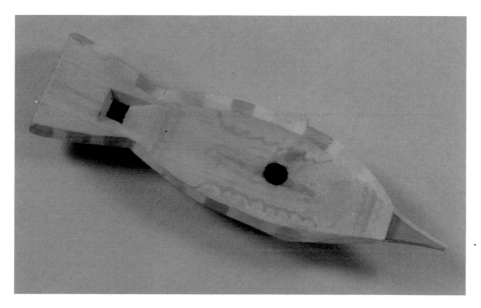

Bird, 5 1/4" x 1 1/2" x 3/4", with two tones. Made in Yugoslavia. (#436) *10~15*

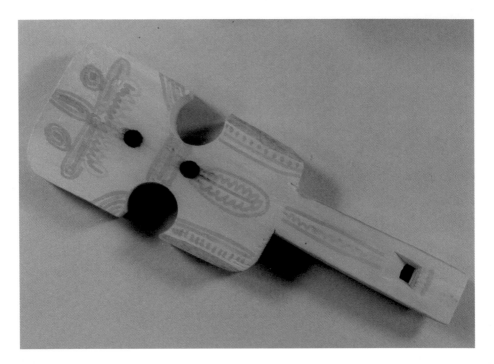

Guitar, 6 1/8" x 2" x 5/8", with three tones. Made in Yugoslavia. (#437) *10 ~ 15*

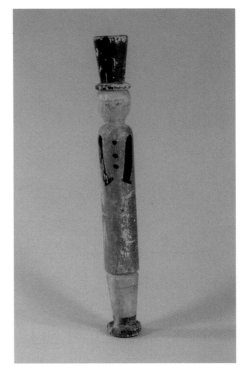

Soldier, 8 1/2" x 1". Made during the 1930s. (#438) *20 ~ 30*

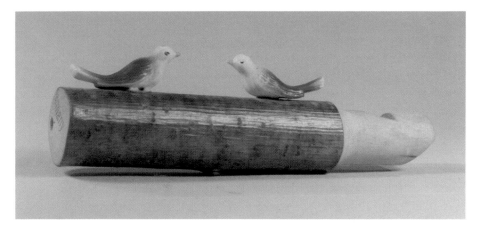

Birds, 5 3/4" x 1", two tones. Made in Germany. (#439) *10 ~ 15*

Handmade in India, 3" x 5/8", two tones. Still made today. (#440) *2 ~ 3*

Handmade in India, 3" x 1/4", two tones. Still made today. (#441) *2 ~ 3*

Handmade in India, 3 1/8" x 3/4", three
tones. Still made today. (#442) 2-3

A whistle with a train sound, 4 1/4" x
1 1/2" x 1", three tones. (#443) 15-20

Pipe, 2 1/2" x 1" x 1", with a wooden
bowl and a plastic stem. (#444) 15-20

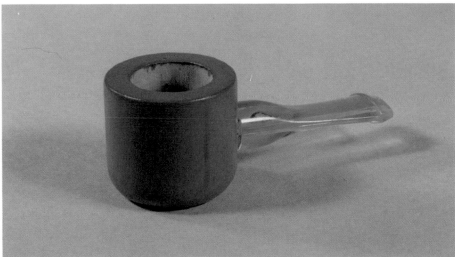

Organ. This is one of the small pipes of a old pipe organ, the black tip was to adjust the pitch. This one has two tones. (#445) *20-30*

Wooden whistle, 3" x 2", made by the Quelle Est Belle Company in France. When you blow on the end, it sounds like a turtle dove. Still made today. (#446) 20-25

Makes a train sound. Two tone 5" long hand carved made of cherry wood by Mossy Creek Woodworks of Wesley, Arkansas. Still made today. (#447) 10-15

Wooden whistle, 3 1/2" long, made by the Quelle Est Belle Company in France. When you blow on the end, it makes a sound like a little owl. Still made today. (#448) 26-25

Wooden whistle, 4" long, made by the Quelle Est Belle Company in France. When you blow on the end, it makes a sound like a cuckoo. Still made today. (#449) 20-25

Wooden whistle, 3 5/8" long, made by the Quelle Est Belle Company in France. When you blow on the end, it makes a sound like a yellow warbler. Still made today. (#450) 20-25

Wooden whistle, 2 3/4" long, made by the Quelle Est Belle Company in
France. When you blow on the end, it makes a sound like an American robin.
Still made today. (#451) 20-25

Clown, 4" x 1/4" x 5/8". Made of wood and hand painted in Sevi, Italy. Still made today. (#452) *8-10*

Tree branch, 4 3/8" x 7/8". (#453) 6 - 8

Wooden stick, 9" x 5/8". (#454) 3 - 5

Penny whistle, 2 3/4" x 3/4", sold for one penny in 1930. Made in the U.S.A. (#455) 15 - 20

Price Guide

Item No.	Value (U.S. $)						
1	15-20	47	25-35	93	10-15	139	15-20
2	15-20	48	25-35	94	1-2	140	10-15
3	5-10	49	5-10	95	1-2	141	35-45
4	5-10	50	5-10	96	1-2	142	20-30
5	2-4	51	10-15	97	10-15	143	20-30
6	4-6	52	10-15	98	10-15	144	30-40
7	5-10	53	15-25	99	.25	145	5-10
8	10-15	54	5-10	100	10-15	146	10-15
9	10-15	55	10-15	101	25-35	147	10-15
10	10-15	56	1-2	102	.50-1	148	10-15
11	15-20	57	1-2	103	.50-1	149	20-25
12	10-15	58	10-15	104	.50-1	150	20-25
13	10-15	59	15-25	105	15-20	151	5-10
14	3-5	60	.50-1	106	25-35	152	1-2
15	3-5	61	15-20	107	25-35	153	10-15
16	15-20	62	1-2	108	10-15	154	15-25
17	2-5	63	1-2	109	30-40	155	20-30
18	15-20	64	1-2	110	15-25	156	10-15
19	25-35	65	1-2	111	15-25	157	3-5
20	30-40	66	1-2	112	15-25	158	2-3
21	25-35	67	60-80	113	25-35	159	1-2
22	25-30	68	5-10	114	10-15	160	5-10
23	2-4	69	15-25	115	5-10	161	2-4
24	8-10	70	15-25	116	15-20	162	2-4
25	15-20	71	5-10	117	15-20	163	5-10
26	8-10	72	15-20	118	60-70	164	15-20
27	8-10	73	5-10	119	15-25	165	5-10
28	8-10	74	5-10	120	15-25	166	5-10
29	10-20	75	5-10	121	20-30	167	2-4
30	10-15	76	2-3	122	30-40	168	2-4
31	10-15	77	25-35	123	15-20	169	3-6
32	10-15	78	30-40	124	10-15	170	10-15
33	2-4	79	20-30	125	10-20	171	10-15
34	3-8	80	40-60	126	25-35	172	10-15
35	2-4	81	40-60	127	15-20	173	.25-.50
36	10-15	82	.50-1	128	15-20	174	.25-.50
37	20-30	83	2-3	129	25-35	175	5-10
38	3-5	84	15-25	130	35-45	176	3-5
39	3-5	85	25-35	131	40-50	177	1-2
40	1-2	86	15-25	132	20-30	178	5-10
41	15-20	87	35-45	133	40-50	179	3-5
42	10-15	88	5-10	134	40-50	180	1-2
43	15-20	89	55-65	135	20-30	181	5-10
44	25-35	90	10-15	136	40-50	182	5-10
45	25-35	91	45-65	137	15-20	183	3-4
46	25-35	92	10-15	138	25-35	184	2-3

No.	Value	No.	Value	No.	Value	No.	Value
185	1-2	253	20-30	321	15-20	389	60-70
186	1-2	254	60-80	322	20-30	390	5-10
187	15-20	255	20-30	323	5-10	391	10-15
188	5-10	256	15-20	324	15-20	392	45-65
189	3-5	257	80-90	325	5-10	393	40-60
190	2-3	258	80-90	326	5-10	394	5-10
191	10-15	259	10-15	327	10-15	395	10-15
192	1-2	260	10-15	328	25-35	396	15-25
193	2-3	261	10-15	329	3-5	397	40-50
194	10-15	262	30-40	330	3-5	398	10-15
195	10-15	263	40-60	331	5-10	399	5-10
196	10-15	264	20-30	332	5-10	400	20-30
197	2-3	265	50-70	333	3-5	401	20-30
198	1-2	266	100-15	334	3-5	402	20-30
199	3-5	267	35-40	335	10-15	403	3-5
200	5-10	268	30-35	336	5-8	404	30-40
201	5-10	269	25-35	337	5-10	405	10-15
202	20-30	270	20-30	338	30-40	406	15-20
203	1-2	271	20-30	339	25-35	407	20-25
204	1-2	272	40-50	340	20-30	408	12-20
205	1-2	273	15-25	341	2-3	409	10-12
206	1-2	274	15-20	342	30-40	410	15-20
207	1-2	275	15-20	343	25-30	411	3-5
208	5-10	276	20-25	344	20-25	412	50-60
209	5-10	277	10-15	345	15-20	413	35-45
210	20-30	278	10-15	346	30-40	414	80-100
211	1-2	279	10-15	347	25-30	415	10-15
212	.25-.50	280	10-15	348	25-30	416	20-30
213	.25-.50	281	10-15	349	10-15	417	30-40
214	10-15	282	10-15	350	10-15	418	30-40
215	10-15	283	3-5	351	20-25	419	25-35
216	30-40	284	3-5	352	15-20	420	25-35
217	15-20	285	3-5	353	15-20	421	.25
218	10-15	286	3-5	354	10-15	422	.25
219	10-15	287	20-30	355	10-15	423	.25
220	10-15	288	80-100	356	10-15	424	.25
221	10-15	289	40-60	357	10-15	425	.25
222	10-15	290	40-60	358	15-20	426	3-5
223	10-15	291	15-20	359	1-2	427	3-5
224	10-15	292	5-10	360	2-5	428	1-2
225	10-15	293	20-30	361	5-10	429	.25
226	15-20	294	25-35	362	1-2	430	.25
227	15-2n	295	60-80	363	1-2	431	.25
228	10-1!	296	60-80	364	5-10	432	.75
229	5-10	297	40-60	365	300-400	433	1-2
230	5-10	298	25-35	366	200-300	434	1-2
231	5-10	299	5-10	367	20-30	435	1-2
232	5-10	300	3-5	368	20-30	436	10-15
233	5-10	301	2-3	369	40-50	437	10-15
234	5-10	302	15-20	370	20-30	438	20-30
235	10-1	303	15-20	371	20-30	439	10-15
236	5-10	304	30-40	372	15-20	440	2-3
237	15-20	305	.25	373	15-20	441	2-3
238	5-10	306	2-3	374	15-20	442	2-3
239	5-10	307	25-35	375	5-10	443	15-20
240	10-15	308	5-10	376	10-15	444	15-20
241	1-2	309	5-10	377	10-15	445	20-30
242	60-80	310	5-10	378	5-10	446	20-25
243	20-30	311	5-10	379	30-40	447	10-15
244	25-35	312	20-30	380	5-10	448	20-25
245	25-35	313	5-10	381	10-20	449	20-25
246	20-30	314	3-5	382	2-3	450	20-25
247	25-35	315	3-5	383	3-5	451	20-25
248	15-20	316	5-15	384	20-35	452	8-10
249	15-20	317	5-15	385	5-10	453	6-8
250	5-10	318	5-10	386	30-40	454	3-5
251	20-30	319	15-20	387	80-100	455	15-20
252	15-20	320	5-10	388	25-35		

425 .25